1986

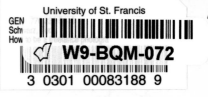

How to Be a
Freelance
Photographer

How to Be a Freelance Photographer

by
Ted Schwarz

Contemporary Books, Inc.
Chicago

Library of Congress Cataloging in Publication Data

Schwarz, Theodore.
 How to be a freelance photographer.

 Includes index.
 1. Photography, Freelance. I. Title.
TR690.2.S34 770'.23'2 79-8751
ISBN 0-8092-7063-3
ISBN 0-8092-7062-5 pbk.

Published by Contemporary Books, Inc.
180 North Michigan Avenue, Chicago, Illinois 60601
Manufactured in the United States of America
Library of Congress Catalog Card Number: 79-8751
International Standard Book Number: 0-8092-7063-3 (cloth)
 0-8092-7062-5 (paper)

Published simultaneously in Canada by
Beaverbooks
953 Dillingham Road
Pickering, Ontario L1W 1Z7
Canada

Contents

How to Be a Freelance Photographer

1
Introduction

Mention freelance photography to a group of camera owners and their reactions will show you have touched a deep-seated fantasy they have harbored ever since they started taking more than an occasional snapshot. Some have imagined the thrills of international travel. They see themselves, camera in hand, flying to Los Angeles one day, London the next, and Paris after that. Others have merely marveled at the beauty and professional quality of the slides they took during a vacation at some scenic wonderland just a few hundred miles from home and asked why they couldn't sell them to some publisher. Yet, whether the dream of freelancing is for a career or just an occasional sale, few if any camera owners seriously believe they will ever earn money with their equipment this way.

The fact that you are reading this book means that the dream of freelancing is within you. Perhaps you have slides of scenic splendor or urban studies with the impact of a Pulitzer

Prize winning news photographer's work. You might have a picture series of a neighbor who has triumphed over adversity or close-up renderings of the microscopic beauty found in nature. Perhaps pretty girls or handsome men have been your subjects, and you want to do more with their portraits than just let your friends admire them. Whatever the case, you want to reach out to a larger audience. You want to sell your work to magazines, book publishers, and other markets, either on a part-time basis or as a major source of income. Yet, you are not certain it is possible for you to reach this goal or that you should even be harboring it.

Although it probably seems difficult to believe right now, the truth is that freelance photography is within your grasp. It doesn't matter what sort of camera you own, it doesn't matter whether you have one perfect image you want to share with others through publication or if you have hundreds of pictures on a vast array of subjects, all of which would be of interest. There is a market for your pictures and this book is going to tell you how to determine both what that market might be and how to sell to it.

I think what I enjoy about freelance photography, beyond the checks and the thrill of seeing my by-line or photo credit under a picture, is the fact that the only criteria for acceptance of my work is that it fits a publication's needs. No one cares whether I am a man or a woman. No one asks me what my education might have been. No one cares if I am young or old, what my religious beliefs might be, the type of car I drive or the camera I can afford to own. All that matters is the images I take. If they fit the needs of a particular publication, my photographs will be purchased. If they don't fit the needs but are of high quality, someone else will buy them. It is the work you create that determines acceptance, not some arbitrary value unrelated to the picture.

Today, after twenty years of freelancing, I use some of the finest cameras made. My work appears in publications throughout the world, and I regularly travel to different cities on assignments related to books and magazines. However,

when I first started *successfully* freelancing, I was using a camera that I bought for $35—about double what it was worth—at a discount store. I had no light meter, so I had to guess my exposure, which wasted a lot of film. The lens was like pop bottle glass except for the center so I never took a picture with anything important showing at the edges of the image. Yet I managed to sell my pictures to newspapers, television stations, and magazines. I didn't sell much, and I didn't earn very good fees; but I did sell. More important, better equipment would not have made a difference at that time. The pictures that sold were the ones that were right for those publishers, and I wouldn't have done anything different had I owned a camera costing twenty times the price I paid for mine.

My current work also reflects one of those paradoxical realities of freelancing. The formal education necessary to become a staff member of some of the magazines that regularly buy my photographs is so high that I do not qualify. I have actually been rejected for regular employment in times past by companies that proceeded to pay me more to freelance than I would have earned with a salary. I don't meet the standards for a full-time job, but when I freelance, all that matters is what I have achieved with my manner of seeing. In fact, I know of an eight-year-old boy who sold drag race photos to a magazine interested in hot-rod cars, and I know an eighty-year-old man who sells nature photographs to wildlife publications. The editors always want to see more of their work. Yet obviously neither would ever be hired as a full-time employee by the publishers who send them checks.

Perhaps the biggest concern held by most photographers interested in freelancing is what equipment they should own. There is a feeling that you *must* have the latest titanium marvel coupled with a motor drive, optics made in space, laser beam focusing, FM stereo music, and a fold down camper that sleeps four. This theory is encouraged by the manufacturers who want you to constantly buy the latest model equipment. Their advertising shows Wanda Wanderlust and Tom Truckin,

globe-trotting photographers, talking about how it would have been impossible for them to record the stampeding herd of wazmans on top of Mt. Blowitoutyourear without their five speed, front wheel drive, jet propelled, six lens, two back Leiconflex camera. What is not mentioned is that excellent photographs have been taken for decades with far less sophisticated cameras. The ads also ignore the fact that the "state of the art" today will be simplistic nostalgia in ten years.

The most important piece of equipment you own is your eye. A quality photograph is determined by how you look at the world through your camera. If the pictures you are taking seem to you to be as good as the ones being published in magazines, and in some cases they may seem to be better, then there is no reason you cannot freelance.

A camera is a tool, and the selection of that tool should not be left to an advertisement's pressure or an arbitrary dollar value. Freelancers have used cameras ranging from an elaborate pinhole camera (Yes, the photographer's scenics regularly hang in galleries) to 35mm, roll-film, and large-view cameras, usually used for nature work. Probably the majority of pictures are taken with 35mm SLR's since they are so extremely versatile. Roll-film cameras, both twin lens reflexes and SLR's, run a distant second.

The advantage to the 35mm SLR is that it is readily adaptable to any picture taking session you might encounter. A camera and normal 50mm lens can take excellent images covering a wide range of subjects. If you need to change your perspective for either increased creativity or personal safety, such as when photographing sporting events, a variety of optics are available. Many of the newer cameras also utilize inexpensive power winders or more elaborate motor drives that make it easier to take pictures of rapidly moving events. Some have interchangeable viewfinders and focusing screens.

Each attachment available for a camera makes the camera more versatile. Each lens increases your perspective. But a good picture is a good picture regardless of what you did to take it.

There are two types of freelance activities you are likely to pursue after reading this book. One involves the sale of an occasional photograph. The other involves accepting assignments. In the case of the latter situation, you should try to have at least two cameras using the same interchangeable lenses. Not only does this allow for the use of color and black-and-white film simultaneously, it also insures that you will have at least one camera body to use in case of equipment failure.

Most publishers are unconcerned with the format you use for your pictures. At one time, the larger sized formats such as 4 x 5 were essential because of problems with both film quality and printing techniques. However, today that has changed. Book and magazine publishers will accept 35mm slides, though many magazines, especially overseas markets, want Kodachrome when you use color slides. This is because Kodachrome has the least grain and reproduces as flawlessly as larger formats when properly printed by the publication. However, Kodachrome is limited in speed and higher speed films such as the Ektachromes are often essential.

Color negative film must *never* be used for magazine assignments unless specifically requested. The reproduction of prints is difficult at best and may be impossible for some publications when a surface texture other than "glossy" is used with the prints.

The one exception to the small format occurs when you want to sell photographs to stock photo agencies as is discussed in a later chapter of this book. Stock photo agencies report that they can get more money for a large transparency than they can for a small one. If they have identical 35mm, roll-film, 4 x 5, and 5 x 7 transparencies, most clients will pay the most money for the 5 x 7 size. However, stock agency sales are the least likely to be profitable for the average freelance photographer. So this should not be a primary concern.

Black-and-white prints are desired in 8 x 10 format. The 8 x 10 print (8 x 8 with the uncropped 2¼ x 2¼ roll-film camera) can be easily handled, retouched, and prepared for

reproduction. It also fits easily into a normal file folder for easy storage.

The choices of black-and-white or color images for magazine and book use is determined by the publication. It costs more money to print color images than black-and-white and many publications have eliminated color except for advertising pages and special features. Sending nothing but color work can prove detrimental. You must always study the publication carefully, seeing what they are running, and then submit accordingly. Even a magazine publishing color will have a greater need for black-and-white unless color is essential to the story told in your images. Color is never run for its own sake but only because it enhances the story. For example, if you sell a series of images of an artist at work, color may enhance the pictures that feature his or her work. This is especially true if the person is a painter who relies on vibrant hues. On the other hand, a straight portrait of the artist would not be particularly desirable in color. Such a picture is basically a record photograph, and black-and-white provides all the information the viewer would be interested in.

Black-and-white photographs should always be made into a contact sheet when you are taking film for an assignment. A contact sheet is made by cutting the negative into strips in the lab and printing the strips on a single sheet of photographic printing paper. Thirty-six exposures will be printed from a roll of 35mm film, and twelve from a roll of 2¼ x 2¼ film. You study the sheets, then have enlargements made only from negatives appropriate to the particular story. At times, the editor will want the contact sheets when you have been on assignment. Other times, only the prints will be desired. However, this is much cheaper than having individual prints made from each frame.

2

Understanding Media

One of the keys to successful freelance photography is to truly understand the markets your pictures are aimed at. The majority of photographs you sell will go to newspapers, magazines, and book publishers. To a lesser degree there may be an occasional sale to television, but these are infrequent. Most television stations insist upon motion pictures when at all possible. Still photographs are used only when film or videotape of an important event is not available.

Newspapers are your closest resource of freelance sales since they are published in almost every community in the nation. Some are daily papers while others come out weekly. Major metropolitan areas are served by papers with a large staff of writers and photographers who blanket the area when looking for news and features. Smaller dailies may have only a handful of employees covering community events, so the editors assign priorities because the paper is usually short handed. Weekly newspapers frequently have one person who

handles both writing and photography. This person covers all events of importance within the community, adding usually rewritten press releases from clubs, civic organizations, and other groups to the news. Each paper will buy freelance submissions, but what they pay and what they can use will vary with the size and budget of the publications.

Anyone who has not worked for a newspaper has the illusion that the publication's primary concern is presenting the news. This is only partially true. A newspaper is most concerned with advertising. The more advertising space that is sold, the more room there is for news and features. If there is enough news to fill a hundred pages but advertising to pay for only half that amount, then fifty pages of news will have to be dropped.

What all this means to you, the photographer, is that space will always be at a premium. If you take a photograph which has visual impact only when reproduced to an 8 x 10-inch size, it is unrealistic to expect a newspaper to run it at that size. It will either be rejected or run to fit whatever space is available, a space which could be as tiny as one inch square. The impact is destroyed, though that fact is not considered important to an editor who must work with whatever space he or she might have. It is the photographer's job to adjust the way a picture is taken to fit the editorial space rather than expecting a newspaper to readjust its space to print your photograph for maximum visual impact.

Photographs taken for general newspaper use must be cropped tightly in the camera. A good rule to follow is to try never to get more than two or three people in any picture and, even then, make certain they are close together.

The easiest way to illustrate this situation is to use the example of a publicity photograph you have taken for a theatrical company featuring melodramas. The scene is one in which a damsel in distress is bound and gagged at the back of the stage, midway between the wings. The villain is standing stage right, pointing a gun at the hero who has just made his entrance at stage left. The villain and the hero are as far from

each other as possible while still remaining visible to the audience. The heroine is angled like the midpoint of a "V" so that she is to the rear of the stage, quite far from the other two.

In order to capture the visual drama of the play, you will probably be located in the audience area, either standing midway to the back with a normal lens or working close to the stage with a wide angle lens. Either perspective will result in the characters on stage being a tiny portion of the final print. Unless an 8 x 10 enlargement is run from the picture you take in this manner, it is likely the people will seem to disappear. The newspaper is highly unlikely to give you such space.

The alternative is for you, the photographer, to take control of the situation. You rearrange the cast during a special picture session. The damsel in distress is brought closer to center stage. Then the villain and hero are positioned in front of her. The villain is to one side of the bound and gagged woman, pointing his gun at the hero who is on the other side of the victim. They are as close together as they can be without anyone blocking anyone else. When you frame them, there is no extraneous background in your viewfinder. You will move in close to three people directly interacting. When this is physically reduced for reproduction in the paper, all three actors are clearly visible and the emotional impact of the scene is conveyed to the reader of the newspaper.

Most photographers trying to sell photographs to daily newspapers make the mistake of attempting to sell spot news photographs. These are usually the least important to the paper unless you find something unusual. For example, suppose a major fire breaks out in the leading department store in your community. You are a block away when you see the smoke, have a camera and arrive at the store about the same time that the fire engines get there. You begin taking pictures, working perhaps a half hour before the newspaper photographers arrive. You go to them and say that you have been taking pictures from the time the fire department arrived

and ask if they feel their editor might wish to buy them. But will the editor?

The basic philosophy of all daily newspapers is to run all departments the way a profit-making business should be run. A staff photographer is expected to produce full visual news coverage so there is no need to spend money for outside pictures, if possible. If several news stories break, each requiring pictures, and the staff is too small to meet the demand, freelance assistance may be welcome. Usually a freelancer will not be called, though. A story can be run without illustrations. Illustrations will be used only if a freelancer stops at the event by chance and then comes to the paper with the film, processed or not. If there is any chance that the staff can handle everything, no freelance work is considered. This ensures maximum utilization of employees whose salaries are being paid regardless of productivity. Using freelancers regularly could result in idle time for the staff, the photographers continuing to receive pay even though they're not taking pictures.

The exception to this situation would be if you obtained something unusual during that interval prior to the arrival of the newspaper staff photographer. For example, suppose a fireman fell through the department store roof, and you caught the image. Or someone might have leaped, and you recorded the falling body. Or a massive explosion might have hurtled the side of the building into the street, and you obtained a picture. All of these situations would have tremendous visual impact, would be essential illustrations for the story, and would be considered far more newsworthy than routine coverage of the flames being doused. In such a case, your pictures become unique and the editor will delight in purchasing them.

A second exception occurs when you chance into a news event that is over by the time it is known. For example, I once was in a Cleveland, Ohio, camera store where some detectives were buying film. They were talking about having to get to the airport on Saturday morning at a very early hour. They

were discussing the fact that the president's daughter was passing through by commercial passenger plane and would have to change from one airliner to another because of her destination. She would be taken from the first plane to a VIP lounge area, then to the next plane after her short layover. No one was to be notified that she would be coming through—no press conferences or other public awareness. However, she would deplane like anyone else, and I knew that the airport had an observation deck from which I could take photographs.

That Saturday morning I arrived at the airport with my camera and a 135mm telephoto lens. I went to the platform and began taking pictures as any camera buff or tourist might do, and several such people were also there. I noticed a number of uniformed police officers as well as several men who looked as though they were either plain clothes detectives or Secret Service agents. I kept casually snapping pictures of arriving flights, watching the men from the corner of my eye.

Suddenly everyone seemed to tense. They positioned themselves on the observation deck and just outside the airport building entrance, watching the crowd for possible problems. I put a fresh roll of film in my camera, leaned over the side and waited. Moments later a plane landed and the door opened. Out came several people including the president's daughter and the Secret Service agents accompanying her. They made their way down the ramp, giving me several clear photographs that were complete exclusives. None of the casual snapshooters recognized her.

I waited to do anything with the photographs until the president's daughter boarded the next flight she was to take. As soon as the plane left the ground, I bolted to the telephone and began calling newspapers and television stations. I contacted the newspaper editors and the television station news department to tell them what I had and to ask them what they would pay.

I would like to say that the story has an ending of instant success, but it doesn't. The first station I contacted was a part

of the NBC Television Network and happened to be Number 1 in the news ratings. The News Director said, "We don't know anything about the president's daughter passing through Cleveland. If we don't know about it, it didn't happen." He didn't care about the fact that my knowledge was the result of a chance overhearing of some detectives. He didn't even care to take the time to call and check on what I had to say. He simply felt that somebody would have notified the station in advance or the situation could not have taken place.

The next call I made was more successful. Again no one believed me, but I had learned my lesson from the first experience. I insisted that the station personnel check with their sources. Then I called back thirty minutes later, and they confirmed that I was right, though they were still surprised. They also bought exclusive television rights to the pictures, arranging to pay me for each picture shown on each newscast.

I raced to the station with my exposed but unprocessed film, which the station camera crew processed and printed for me. Five prints were selected for the 6 P.M. news show and three for the news scheduled at 11 P.M. Several images were rejected, and these were sold to the morning newspaper. Altogether I made $100, a fair amount because the news was not particularly important. I just had pictures of her going up and down a plane ramp. Their appeal was the exclusiveness of the story.

A different situation occurred with a freelance photographer who worked full time at a factory and moonlighted with his camera. A strike was going on at his plant and out of state labor organizers had moved in, trying to create a more violent atmosphere. The head of the labor group knew the police were moving in to stop the problem, and he did not want to be caught with the gun he carried. While the regular news photographers were absorbed with the excitement of the police moving through the line of pickets, the labor leader reached under his shirt, removed his revolver and passed it on to an accomplice who was less likely to be searched. None of the photographers saw it, but the freelancer managed to squeeze off five frames before the gun was hidden again.

This time the news story was major. The photographs were proof not only of the violence the management of the company feared but also that the labor leader was trying to cause serious trouble. No longer could the union headquarters claim that the top people were innocent of trying to start violence. The photograph was a major spot news image and eventually won a number of awards.

The photographer of the union official sold the photograph twice. The first time was to the afternoon newspaper in the city where the violence took place. He made $75 for the use of a single image, then was shocked to discover the editor didn't have the courage to run the picture as taken. It was cropped so that only the labor leader's head showed. "Too controversial" was the way the editor tried to justify not using the full frame revealing the gun transfer.

The photographer took his negative to the nearest large city, sixty miles away, and sold the picture to the morning daily where it was run in its entirety. That was the photograph that won the awards, and he earned more than $200 for that single use. The cropping had been so severe with the other newspaper that there was no copyright problem whatever.

Such spontaneous news images are true chance events. I have taken photographs almost twenty years, and several times I have encountered fires and other news events. However, with the exception of the president's daughter series, the result of an overheard remark, only once have I taken anything unique enough for a newspaper to buy my work over that taken by a staff photographer. This was a cave-in at a construction site where I recorded the rescue of two men, one of whom later died from his injuries, before the staff photographer arrived. It was my recording of the man who died that gave my photos a stronger human interest appeal.

The point of all this is that if you try to sell newspapers spot news, it is going to be a chance sale. You should not attempt to compete with staff photographers on a regular basis because it will not work. The economics of the news-

paper *business* are such that the staff's work must always be given priority.

There is a variation of the spot news sales that can bring you a regular paycheck with your camera if you live in a relatively isolated area. Major city newspapers like to provide coverage of every community within their circulation area. Most large metropolitan dailies are sold in smaller communities throughout at least part of the state, including communities that might have a paper of their own. They want to give broad coverage so that readers in the surrounding community will buy the metropolitan daily, either in place of or in addition to their local paper. The afternoon daily, in the example of the labor union photograph, was sold almost exclusively within the community where it was based. But the morning daily paper in the nearby city where the photograph eventually appeared was also sold within the confines of the city housing the afternoon paper. The papers did not compete directly for readers since most people either buy a morning or afternoon newspaper, or both.

The result of this situation of papers trying to cover more territory than their immediate surroundings means that there are frequently openings for what are known as *stringers*. The term stringer technically relates to writing. Freelance writers working for newspapers on a per article basis are paid by the number of inches of material their space fills. Articles are divided into columns, the width of which determines the number of words. Rather than counting the number of words or lines within the article, a count is made of the number of inches of material used. The article(s) is clipped from the paper and cut further into columns. The columns of any given freelancer were once taped together, one after the other, and the total length was measured. Then the check was issued according to this length. Since the columns were taped or *strung* together, a person who worked in such a pay situation was known as a stringer. However, the term has been mildly corrupted so that anyone who works regularly for a newspaper, selling either by the article or by the photograph, is called a stringer.

If you live in a community where a daily newspape.
but not produced, there is a chance that you could be.
stringer for the daily. This means that, in a sense, you w
become a part of the paper's staff though with no guarante. of
a regular paycheck and no benefits such as insurance or
pension fund. Whenever an event is going to take place in
your area, and this can mean anything from a special session
of the city council to a neighborhood carnival to the photog-
raphy of a storm that has struck several communities, you are
the person assigned to photograph it. You also initiate picture
ideas, such as photographing fires or other spot news events.

The pictures you take may be used on the regular news
pages if important. More frequently they will be used in
special sections devoted to your area. Many newspapers print
special editions with pages devoted to a particular community.
One paper will be circulated in the city limits. A second
edition, identical except for one or two pages, will be circu-
lated in your community. These altered pages will contain
local news primarily of interest to your neighbors. These same
pages will be printed with yet different news and pictures for
a different community also served by the paper. This regional-
ization helps the big city daily compete to a degree with the
daily or weekly paper in a nearby small town.

Stringers usually can count on a set income from freelance
work each month although that income will be relatively low.
When so much news and so many picture stories are generated
from an area that the editor is innundated with good material,
a full-time reporter or reporter/photographer will be assigned
and a mini-office rented. You might be offered a full-time job
at this time or someone might be transferred from the news-
paper's main office.

The third type of photo sale you can make to a daily
newspaper is the most commonly purchased. This is the
feature story. It can be about anything of interest to the
readers, and the term *interest* is taken in its broadest sense. For
example, a newspaper in Florida might run black-and-white
pictures of your Wisconsin vacation if they are coupled with
an article relating how the readers can enjoy the same vaca-

tion. The material might be an actual article, or it might be lengthy caption material. The local tie is the fact that the reader can share the experience by taking his or her vacation in the same area.

Feature stories always differ from spot news in that they are not so carefully timed that they must be in the paper on a certain date. For example, among the features I have done are stories on a ninety-year-old woman who is blind yet continues sewing and a twenty-year-old woman who teaches gymnastics from a wheelchair. These are people who were interesting yet whose stories could be run either in July or December without being any less timely.

The way in which a photo feature will be used depends upon the size of the daily paper and whether or not there is a Sunday issue as well. Many Sunday newspapers are produced with a local magazine supplement. These are local equivalents of such national publications as *Parade* magazine. They frequently seek material from readers and, in the case of large city papers, will often use color photographs, not just black-and-white.

Color reproduction is expensive for all publishers, and many magazines have cut back the number of color pages that they use. Newspapers are using an increasing amount of color, but the cost is so prohibitive that it is carefully planned and almost never open to freelancers. There may be one or two color images in the body of the newspaper on Sunday. There may be color scenics used for emphasis on a holiday or other special events. However, this will be a single image taken by a staff photographer and planned around a specific theme.

The locally produced Sunday magazine often has a little higher budget because of the type of advertising it attracts. The cover may be in color, and there may be regular or periodic space devoted to color from freelancers. Thus if you are trying to sell color, the editor of this section of the newspaper is probably the only one who will express an interest. Even then, the cost of reproduction is so great that the pay will be minimal. You should make it a practice to

always keep your camera loaded with black-and-white film, using color only on those occasions when you are on assignment for the paper and the editor says color is needed.

Newspapers and magazines can seldom predict how much space will be devoted to a photo story. What is originally conceived by an editor as a brilliant, multipage spread of pictures may suddenly be crowded out by late-breaking news, leaving room only for a single photograph. Even worse, that single photograph may have been conceived as a horizontal and the picture you sent is a vertical. As a result, it is essential that you take photographs based on all possibilities.

The most important photograph you submit is actually an overview of the story you are covering. One image, taken both horizontally and vertically when possible, should reveal everything the reader needs to see in order to understand what is happening. This is true whether you are sending a picture series to a newspaper, magazine, or other publication.

For example, I once photographed a men's hairstyling club. The barber/owner of the club had a building in which there were a series of booths for customers, each of which had a window overlooking a stage. As the customers had their hair cut, a belly dancer would entertain. This was not a glorified strip tease but classic middle-eastern dancing. However, the situation was so unusual, I had to convey what was happening in a single photograph.

My answer to the dilemma was to work with a wide angle lens from a position in which I could photograph the essential elements of the story. My picture showed the barber working on the customer's hair with the belly dancer on stage, framed to the right. This was taken once from a horizontal and once from a vertical camera position. Then I went around to the stage area, moved into a corner and photographed so the belly dancer would dominate the image. Just past her, clearly visible, was the customer with the barber cutting his hair. Again, both horizontal and vertical images were taken to insure that the picture would fill any available hole.

Once I had the single photograph that conveyed the impact

of the story, I proceeded to take additional images that could be used in a larger spread. I took pictures of the barber at work, the customer having a drink while waiting for his haircut, the dancer at work, and more overviews of the area. When I was finished, I had enough photographs for a full picture story as well as photographs that could stand alone if the space needs changed.

All the photographs meant to stand alone if space was tight were planned to limit the number of people shown. Never were there more than three people, and they were always close enough together to allow for reproduction in a small space. The additional photographs included some that had to be run fairly large, but there were enough others to allow for the discarding of those pictures should space be limited.

There are three individuals most concerned with feature stories for newspapers. These are the people to contact when you have this type of work available. The first is the managing editor; the second is either the editor of the Sunday magazine supplement or the editor of the Sunday newspaper. (Some Saturday papers have magazine supplements when the paper only publishes six days a week. Some papers have one editor responsible just for Sunday material in all departments. Other papers have an additional editor responsible for the magazine supplement.) The third person is the editorial director of a newspaper syndicate.

The managing editor of a newspaper is almost always the person responsible for buying feature material from outside sources. Sometimes he or she acts as a screening unit, eliminating inappropriate material before passing the freelancer on to whoever runs the department where the pictures might be used. Other times the managing editor has total authorization to make a purchase. He or she will buy the work, decide where the pictures will run, and pass them on to the appropriate person for planning exactly when they will appear.

Never rely on anyone other than a top editor for your initial sales approach because no one else has an overview of the paper's needs. The city editor is one of the major editors and

will periodically buy freelance work. However, the city editor seldom has any idea what might be needed in a section devoted to business, real estate, special features on fashion, or anywhere else. The same is true with the head of the photography department although that person's responsibilities extend to the entire paper. He or she must respond to requests initiated by the various departments rather than planning a new feature such as you will offer.

The Saturday or Sunday magazine editor can be approached without going through the managing editor if you so choose. By studying the publication for a few weeks, you will be able to see what kind of freelance material might be appropriate. If you have not saved back issues, check with the main branch of your public library which undoubtedly saves back issues of the newspaper. Occasionally you will have to go to the newspaper itself for back issues, but this is seldom a problem.

Most locally produced magazine inserts will run three different types of photo stories. The first will be staff produced. Read the *by-line*—the credit given beneath the title of an article, which tells who wrote it. Often this will be familiar to you just by reading by-lines spread throughout the paper. Other times there will be the term *staff writer, staff photographer,* or something similar. If there is no by-line, the photo spread was handled by the staff.

Freelance work usually mentions this fact. Along with the by-line will often be a brief note about who the photographer happens to be. Other times the photo credit will read "Cameron Clix Photo" or "Photo by Cameron Clix," when the picture was taken by a local freelancer. If the paper had a staff photographer handle the work, the photo credit may read "Chronicle Journal Photo" or "Chronicle Journal Photo by Cynthia Snapshot." The exact technique varies from paper to paper but is easily recognized by reading a few credit lines and comparing their wording.

Freelance photo features bought by magazine supplements for your daily newspaper will always have local appeal. They will almost never be spot news, nor will they be images the

staff normally covers in the course of the day, such as children frolicking in the first snow of winter. For example, one of my sales to a magazine supplement was a set of images of a dancer leaping about a park. The pictures were taken for other uses, but I had extras I thought the paper might like. They were unusual, could be run any time of the year, and had a strong local appeal. Thus, they were ideal for this type of publication.

The third type of newspaper market is the newspaper syndicate. A newspaper syndicate buys features from freelancers as well as having people under regular contract. These are then offered on an area exclusive basis to newspapers throughout the country. Only one newspaper serving a particular community will have the photographs, but more than a thousand newspapers throughout the United States could conceivably use such material before your checks stop coming in.

Newspaper syndicates are divided into package syndicates and feature syndicates. A package syndicate sells a group of features to each newspaper. There will be several cartoons, editorials, science features, health features, special interest stories, and other items, including photo stories, all sold as a unit. The client pays a set price for everything, and the various contributors receive a fee for their work. A cartoonist with a feature syndicate will be on salary that does not change during the year, regardless of the number of newspapers using his or her creation, for example. Thus any sale you would make will almost always be an outright purchase not based on the number of times it is used.

Regular feature syndicates sell each offering individually. One comic strip might be in 1,100 newspapers while a less popular strip might be in just 300 papers. Editorials, features, and other offerings will likewise be promoted separately from one another. Each creator, and that includes you when you sell a picture story, will be paid based on the price paid per newspaper. Usually, this is a fifty-fifty split, the syndicate taking half the money for its effort and you receiving the

other half. However, this figure varies with the organization. The exact money is not possible to determine because a major city newspaper such as the *Detroit News, New York Daily News, Los Angeles Times,* or a comparably sized publication may pay a hundred dollars or more while the Dead-At-Night, Iowa, *Courier* might pay three dollars. The fee charged is based on circulation. You are benefiting from the total sales rather than from the fee paid by any given publication.

Newspaper syndicates buy photographs of broad national interest. A series of photographs of your town's mayor's daughter taking her first steps may sell to your daily newspaper but would not be of interest in a publication a thousand miles away. However, a photo story of someone who invented and built a one-man helicopter and uses it to commute from his home to his office would be of national interest.

Some photographers like to syndicate their own work, contacting newspapers themselves rather than working through an existing syndicate. This involves contacting the managing editor of each paper, sending copies of the pictures, providing brief captions and whatever other information is needed for the editor to understand the offering. Once the work is published in a paper, you can use a good quality photocopy of the clipping to avoid the cost of sending prints prior to an acceptance.

How do you find where to send your work? The back of this book will have a brief appendix with information on markets. However, I will mention the two publications of greatest interest in this chapter. The first is the annual newspaper-syndicate directory published by the trade journal *Editor & Publisher,* a publication meant for people in the newspaper business. The second is the annual listing of all the newspapers in the United States, also published by *Editor & Publisher.* Both of these are updated around July of each year. The syndicate directory is included within the weekly magazine. The newspaper directory is a bound book sold by direct mail. Most libraries maintain both of these or you can order them

from *Editor & Publisher* at the address listed in the back of this book.

Whether you handle photo stories for newspapers or magazines, there may be a time when the editor wants you to include a brief article to accompany the pictures. This will go beyond the "who, what, when, where, and why" of a caption. It will be a piece of writing able to stand on its own.

A certain amount of writing information is covered later in this book. However, because of a lack of training or inclination, you may wish to avoid having to handle this task. If so, consider working with a local reporter. Many newspaper writers enjoy freelancing as a means of supplementing income. Writers for weekly newspapers are especially pleased to get freelance work because their salaries are so low. These people may not always be the most versatile writers available, but they do understand the medium and know how to communicate in words the way you know to communicate through photography. Contact the city desk of your daily newspaper or the editorial department of a weekly in order to get in touch with potential writers.

Weekly newspapers have greater flexibility in their use of freelance material than will daily newspapers although they also have less money. A weekly newspaper is not attempting to compete with a daily in news coverage. There is no way that spot news can be handled unless an event occurs just before press time. Thus the paper provides a special depth for each article, usually giving an overview of the week's happenings. In small towns without a daily newspaper, the weekly also gives a compendium of the local events.

Most weekly newspapers have staff members who handle a little of everything. The reporter is also the photographer and may occasionally write advertising copy. This person is frequently overworked and occasionally hard-pressed to find enough material to fill the editorial holes being left. There are only so many events he or she can cover; therefore, quality outside material is always being sought. Freelance photographic submissions of interest to the area readers will always be welcome.

The one problem you may encounter with weekly and smaller daily newspapers is pay. I have known newspapers that actually pay less per picture than the cost of having the prints made. Others have a token fee of perhaps five dollars per print. It is conceivable that you could make an 8 x 10 black-and-white picture desired by your local paper, using a single roll of 35mm film to produce it, and sell it for fifteen or twenty dollars. Then you would sit down and analyze the cost of film, processing, printing a contact sheet, making an enlargement, driving to and from the newspaper and all the other hidden factors and find that you actually either broke even or took a slight loss.

There are several answers to the pricing problem, most of which will be handled in a future chapter. The most important is knowing your real cost, a subject covered later. Next you must decide whether or not publication is worth so much to you that you accept any normal fee offered by the paper. (I let them pay the syndicate rate, which is based on circulation.) Third, you must consider whether or not the work can be sold elsewhere.

Photographs sold to several papers usually make money. If the fee per paper is reasonable, the total accumulation of payments will exceed your costs, often by a handsome sum, since only the price of printing each 8 x 10 is consistent. The cost of taking the picture in the first place is spread over several papers and becomes almost nonexistent on a per paper basis.

In some cases, it doesn't matter what price you get. Tear sheets make you real in the eyes of the editors. Appearing in print two or three times, even for very low pay, may be important to your future sales. If this is the only way you can get started, it is better than not being published at all.

Magazine photography falls into several categories. One is illustrative photography for articles and stories. A photograph is taken to order in an effort to specifically relate to a feature being run. This might be a picture of food taken to illustrate a recipe, a photo of a couple running hand-in-hand along the beach to illustrate a love story or even a humorous picture of

a one-man-band to illustrate an article on music. The uses will vary, but the pictures will all be assigned after the magazine is laid out editorially. First will come the acceptance of the articles; then the photo assignments go out.

Illustrative photography is seldom done by photographers unknown to the editorial and art department staffs. Often the photographer will be a staff member. At other times, the photographer is part of a studio that works regularly with the publication. In either case, this is the hardest area to sell your services in unless you are working in the city where the publication is produced.

Cover photography can be an excellent freelance market and can be similar in difficulty to illustrative photography. The latter is true when the editor seeks a particular image for the cover. For example, a glamour magazine may use only specially dressed models for its cover. The hair style is either typical of a certain hair stylist or is identical to one shown inside the issue. The clothing is provided by a specific designer and/or store, and even the model's makeup may reflect specific cosmetics.

The best way to determine a magazine's cover needs is to study the publication's use of covers for the past several months. Look for inside credit lines and any explanations. For example, the glamour magazines always have a small box with the credits, either on the page containing the table of contents or somewhere toward the back of the magazine. This is usually accompanied by a miniature, black-and-white version of the cover so the reader can study the clothing and makeup while reading who created the particular look.

Other publications may have obvious connections between the cover and an inside story. The cover directly relates to a feature or article and again is posed to order.

The third type of publication will have covers that relate to the contents of the magazine but not in a direct way. The romance magazines, for example, always have covers hinting at love. Photography magazines usually will have covers that include a striking visual image. Detective magazines reflect

violence. Magazines related to hospital management will have covers related to the institutional medical field. This relationship means that freelance work is acceptable, though your pictures must be equally appropriate.

Most magazines, with only a handful of exceptions, insist upon color for the cover. Again a color slide is essential. This can be any size although Kodachrome is preferred for 35mm use. Larger transparencies are even better, but a high quality 35mm or roll film slide will find a market.

The difference between selling a slide for cover use and a slide for inside use is with your framing. All magazine covers reserve an upside down L shape for printing essential information. The top of the magazine has the publication's title or logo. Either the right or left side will have information concerning the contents of the magazine. Feature stories will be promoted in this space. In fact, a few magazines utilize an upside down U device so that teasing headlines concerning the captions appear on both sides, the main cover illustration being carefully centered. The current "Cosmopolitan" cover is often typical of this upside down U approach—the single woman centered with the logo directly over her head and information about the contents running down each side of the cover.

A photograph taken for a magazine might be run full frame with the logo worked in. Sometimes this is done with a square photograph taken with a roll film or cropped by the art director. This photo comprises the bottom two-thirds to three-fourths of the cover. A color complimentary to the one used in the photograph is added above the type and the logo printed on top of that space. Such a device is often used with magazines devoted to photography. It is also used with publications sold by direct mail. The need for adding headlines relating to inside stories is strongest with newsstand publications since the publisher is anxious to get you to buy the magazine. If you are not a regular reader, the blurbs relating to the features and articles may encourage you to pick it up.

A photo feature is a series of photographs relating to a

central theme or project. The feature might show something of interest to the readers, such as the photo stories run by *Life* magazine over the years. Or the photos might relate how-to information. This is especially true with a crafts article or a feature that might run in a do-it-yourself such as *Popular Mechanics.*

There are three types of magazines to which you can sell your work, and it is important that you understand each of them. One is the general interest magazine. Such a publication tries to appeal to a broad range of individuals with varying tastes. It is meant to appeal to men and women, young and old, rich and poor. *Life* magazine fit this quality for many years, as did the original *Saturday Evening Post.* *Look* magazine, *Collier's,* and others have also been this way in the past. The *Reader's Digest* is probably the most widely circulated of this type.

A second type of publication is the special interest variety. It narrows its focus to people who share at least one common bond. *Popular Photography* is aimed at camera buffs, *Working Woman* is meant for women who work, whether married or single, and *Coins* magazine is meant for coin collectors. Many coin collectors take pictures as a second hobby, but *Coins* magazine is not going to run camera reviews and *Popular Photography* is not going to tell you about coins, though coins might be included in a series on macrophotography. A special interest magazine always narrows its focus to a small aspect of the reader's life. The only photography bought by the editors will directly relate to this narrow focus.

The third type of magazine is the trade journal. This is a magazine relating to a particular job or business. It is not sold on the newsstands but rather is distributed by mail or circulated within a company. Photographers have such trade journals as *The Rangefinder* magazine, *Studio Photography,* the *Journal of the Professional Photographers of America,* and specialized magazines such as *Industrial Photography* and *Functional Photography. Teacher* is a magazine for elementary school teachers while *Today's Catholic Teacher* is meant for teachers in Catholic schools. *Today's Education* is meant

for school teachers in general other than those working on the college level. A photo feature on a school teacher using military miniatures to teach war strategy to his or her history students will be ideal for *Today's Education*. If the school in which the teacher is using this innovative method is Catholic, then *Today's Catholic Teacher* might be a second market. If the teacher is working with elementary school children, you could sell the pictures to *Teacher*, and if the children are also retarded, *Special Education: Forward Trends* magazine would be yet another market.

The range of trade journals is so broad that every field has one or more. There is *Coin Launderer & Cleaner* magazine, *International Aviation Mechanics Journal*, *Modern Brewery Age*, *Auto Laundry News*, *Progressive Architecture*, and numerous others. It is conceivable that there is a magazine for Mafia hit men although I doubt that many photographers would want to freelance for it. The pay might be great, but their rejection slips could kill you.

Every publication needs photographs, and almost every publication wants freelance photographs aimed at the magazine's audience. Once you learn to read a magazine properly, the subject of the next chapter, you will be able to sell regularly to any number of journals.

Finally, there are the book publishers. Book illustration generally falls into two categories for photographers. One type of book is originated by the photographer and shows his or her unique work. This might be a collection of photographs relating to a central theme, such as recent books on the workings of a firehouse, the training of a ballerina, and the development of a circus star. Or the photography book might be of the how-to variety, telling you how to take better pictures of architecture, take photos of models, or develop film. Both types may rely on a special idea, unique visual perspective, or a well-known photographer's name, such as Gordon Parks, formerly of *Life* magazine, or Arthur Fellig, better known as Weegee the Great, who had collections of their work published.

Other times photographs are sought to illustrate aspects of

books. These might be pictures for use in encyclopedias or specialized books on child development, biography, travel, music, and other general projects. Or the pictures might illustrate cookbooks or other how-to guides. The pictures might also be limited to the jacket, a little like magazine cover and illustration work. Whatever the case, they will be bought from both freelance photographers and stock agencies.

The market for all this work is obviously broad. Thousands of photographs are being purchased daily from freelancers such as yourself. None of the buyers is concerned with who you are, what you do for a living, how old you are or anything else. If the images fit the publications, you will make a sale.

3

Analyzing Your Market

The possibility of selling your freelance photographs to newspapers, magazines, and other publications does not mean that you will be successful in so doing. It is not enough to be able to take photographs of a professional quality. You must also be able to so define your market that you send appropriate images. This requires you to understand how to read a magazine.

For example, take *Family Circle*, a publication with one of the largest circulations in the United States. The magazine is sold in supermarkets and is aimed at women with families. Some of these women stay home to raise the children. Others hold part- or full-time jobs. Some may be the sole support of their families as a result of a reversal of traditional roles, widowhood, or divorce. However, the common link is that they have families and that they are interested in subjects relating to the home such as cooking, crafts, money management, and the like.

Family Circle, at this writing, regularly runs a perfect feature for freelance photographers. This is a feature story on someone who is unusual because of his or her triumph over adversity through, at least in part, family interaction. For example, one of the stories I did for the magazine was on a sixteen-year-old girl who, several months earlier, had been struck by a car. The girl was so severely injured that she theoretically could not live. She spent several weeks in a coma, eventually wasting to fifty pounds. The injury to her leg alone was severe enough to cause death, and it was certain that survival, if it occurred, would mean life as a vegetable.

The parents disagreed with the doctor. Through their tremendous faith and ceaseless work, they managed to bring the girl through her coma and back into the world of the living. She did seem to be nothing more than a vegetable, but they took her into their home swimming pool and began working her limbs. Day after day she grew stronger through the family's efforts. She began to move and then walk and talk. Eventually she went back to school and started competing in marathon races although, according to the experts at the time of the accident, running would be impossible. Too much muscle had been destroyed for her to ever again be able to stand on one of her legs. Yet the girl not only walked, she ran and looked just like someone who had had no injury.

The photographs I took to illustrate the article on the injured girl were carefully planned to show her success. There was no way I could record her past, of course. I did not know about the situation until so long after the accident that there was no way to document her previous appearance and development. However, I did take one set of horizontal and vertical photos of the girl, her brother and her parents running together down the street. This became the lead photograph because it showed both that the girl had recovered and also that the family was running together. The picture, while nothing special, was an ideal overview since it contained hints of all the elements of the accompanying article. It was ideal

for the end the editors had in mind, and that is why it was used.

Once I was certain I had a good overview of the family, I began concentrating on other elements of the story, ever alert for additional general views that might prove better as lead pictures. I photographed the girl working out in the gym she uses almost every day. I recorded the girl and her father, tenderly touching each other during a moment when they had forgotten my presence. I took pictures of the girl handling her homework, typing, working in the garden, and even swimming. All the images showed how normal she is and how well coordinated her body has become again. They also showed family interaction although, as it turned out, they never showed the entire family together because their activities the day of the photo session took them in different directions. My first set of overviews was also the last I was able to get. So starting with that necessary all-encompassing image had been a wise idea.

The final illustrations selected by the magazine's editors included the overview, a picture of the girl working out on an exercise bike, and a picture of the girl and her father, touching each other during a private moment. They had strong impact for the feature and fit the magazine readers' interests.

I have easily sold other articles and photographs for *Family Circle,* but I have also blown it once. The mistake came when I failed to read the magazine carefully enough to recognize the style it sought. The human interest feature it runs each issue talks of triumph in life, but that triumph must be of a specific type. The success story always involves an early triumph followed by failure and then finally success through family interaction.

For example, my failed story seemed to have all the elements of success in the story about the brain damaged girl. This was to be the visual record of a young blind woman who created her own business, is a top salesperson, and also acts as a counselor for both handicapped and normal children in a

major city school system. Any one of her achievements would deserve respect. The fact that all three had occurred and that she was also blind made the story perfect—or so I thought. Unfortunately, I did not read the magazine carefully before trying to sell it.

Family Circle was impressed with the blind woman, as is everyone who meets her. However, despite the fact that she was born with a handicap in one sense, her life had always been one of triumph. She had a twin sister, born without damage, who imitated her. She was always ahead of other children in school. She has known the pain and trauma of a life without one of her senses; yet she has never really been down. She has always been a winner, living life to the fullest and never really knowing setbacks worse than anyone else's.

The end result was that *Family Circle* rejected the story about the blind woman. Unlike the girl who had sustained brain damage, the blind woman was not someone who had found a way to triumph in the face of adversity. The publication wanted to tell its readers about someone who had gone from a high point in life to the depths of tragedy and who then found the inner strength to triumph again. There was family interaction with the blind woman and interesting quotes from her parents, brother, and sister accompanying the photographs. But the approach demanded by the magazine for such features was missing.

A magazine such as *Family Circle* buys photos for other purposes as well. Pictures will accompany recipes and short features, sometimes showing the individual mentioned in the text and other times illustrating the food, craft object, dress, or other item discussed in a how-to-do-it piece. As with a feature story, one illustration must relate in a single image every item of information needed to show the reader what is happening with other pictures serving as supplements that might not be used. For example, in the same issue that showed my pictures of the family of the brain damaged teenager, a section of short features called "Woman's World" ran a brief description of the making of an elementary school cookbook by students in

Clarks Summit, Pennsylvania. The illustration shows the children being taught professional means of preparing the cookbook by a man skilled in printing. The single image shows the cookbook in progress, the instructor, and some children.

Another short feature in that same section has a picture of a woman who made elaborate figures from cooking dough. The figures can be used as candle holders and the single image shows the woman holding the dough objects. Such work can be supplied by freelancers or taken to order by professionals already known to the magazine. It does not matter to the editor so long as the image fits the publication's needs.

A radically different publication is *Playboy*, which also buys freelance material. Everyone associates the concept of the nude centerfold with *Playboy*, but there is actually more to the magazine in terms of potential photo sales for the freelancer if you really study it.

For example, the theater section uses color photographs of new shows being discussed. In one issue, detailing New Orleans and the Mardi Gras, a number of photographs covered those festivities. There were also photographs of football players from the major college teams. These included both posed team pictures and photographs taken during the games. There were also product inserts and single photographs for use with columns.

The major need of *Playboy* and of similar publications is nudes. However, there are always additional photos they can use, provided they relate to the specific purpose of the magazine. In the case of *Playboy*, this means male orientation. *Playgirl* has the opposite sex audience but still retains an interest in the sensual.

The first step in analyzing any market is to sit down with the publication and study it page by page. Look at both the photographs used to illustrate the articles and stories, as well as the advertisements. Often the advertisements are as much a clue to the type of people the publication is trying to reach as are the article illustrations. Advertisers expect results when they spend money to promote a product or service. They study

demographic surveys of readers that pinpoint the magazine buyer's age range, income, purchases, special interests, and other factors. If advertisers feel their products will have an appeal, they will buy space in those publications whose readers seem to make good prospects.

The age range and income are easy to determine. The greater the income, the more someone will spend on luxury consumer goods such as cameras, stereo equipment, expensive sports cars, high quality furniture, fur coats, and the like. Fast cars, top-of-the-line stereo equipment, and expensive liquor shown being consumed by young, expensively dressed couples all indicate people with higher than normal income are reading the publication. They are also likely to be fairly young. Expensive cruises, condominium developments in luxury retirement and resort settings, and similar items are found more in magazines for the older, wealthy individual. Naturally, the clothing shown, the models selected and other obvious clues also tell you who the reader is.

Next see how photographs are used and study the credit lines. Is there a person's name or are all the photographs credited to stock agencies and news sources such as the Associated Press or United Press International? Some magazines rely exclusively on outside business sources such as stock photo agencies without using freelancers. This is because they know that though they will have to pay what may be a high print fee for each picture used, that fee will be much less than the cost of hiring someone to go out and take the pictures. Even when there is a staff photographer for most of the magazine's work, freelance submissions are welcomed. Usually the staff photographer is kept for stories in the area around the magazine's publishing headquarters so outside work has to be handled by others. For example, *Family Circle* has access to any number of New York based photographers. Since I was based in Tucson, Arizona, when I began working for the publication, it was cheaper for them to pay me by the photograph, plus expenses, than to send a New Yorker to take the pictures they needed.

Most magazines pay for their work in one of several ways. A staff photographer draws a straight salary. Freelance photographers who are members of the American Society of Magazine Photographers generally demand rates set by the ASMP. These rates guarantee expenses plus a minimum daily income for the photographer's work. Freelance photographers who make an occasional submission are paid either by the number of pictures used (a set dollar amount given for each color slide purchased and a second amount for each black-and-white), or they are paid by the page. Some magazines pay a fee for each page your work is on, whether one image or four are used. Others pay according to both the number and size of the images selected. A half-page photo earns one fee, a quarter-page photo earns a second, and so forth. If there are six pictures on a page, you get six different fees, the amount for each varying with whether it is black-and-white or color and the specific size.

The fees paid will vary with the importance of a set of photographs and with the number of times your work has been used. Photographs of an assassination attempt against the President of the United States or the crash of a jetliner into a New York City skyscraper would be worth thousands of dollars even to magazines that normally pay no more than a fraction of that amount. More realistic in terms of what you can expect is a rising fee when you sell to a publication with enough frequency to be considered a regular contributor. Someone who sells a single photograph to the publication will get the standard rate. If your work can be used in issue after issue because of the quality of the photograph and frequency of your submissions, then a higher price per image will be paid as a bonus.

Some magazines plan their issues far in advance and order photos to specifically illustrate what they are running. Others will use inserts of scenics, children, babies, families at play, and similar images that can be purchased for file and used according to available space. Still others will buy photo stories—a series of photographs built around a central theme

with a minimum of explanatory copy. Finally, there are some magazines that want photographs to accompany simultaneously submitted articles. In these cases, you or a partner must write the article you are illustrating. All these differences are obvious as you thumb through the publications you have in mind.

It is essential that you try to understand exactly how the editors think before attempting to sell to a magazine. It will do you no good to send magnificent color images of your vacation in the Getawayfromitall Islands to a magazine that uses only staff photographs, because the editor will not buy from freelancers. Likewise, an industrial trade journal is not going to buy a photo feature on a ninety-year-old disco dancer. You must first understand the market and then consider your submissions.

There are several market guides available to acquaint you with magazines beyond those you encounter on the newsstands, on your job, and in the library. These are all listed in the back of the book. However, the three major ones available at this writing are the annually updated *Photographer's Market* and *Writer's Market,* both published by Writer's Digest Books, and the periodically revised *Where and How to Sell Your Pictures* published by Amphoto. These three offer great depth in providing information. For example, pick randomly from a back issue of *Photographer's Market.* (Check the current edition for accurate information. This quote is to show how thoroughly the magazines are covered as an aid to photographers. It is not necessarily a reflection of the quoted magazine's current needs.) The listing for *National Wildlife* magazine begins with its editorial staff, its size, and the date it was established. The latter is important because the longer a publication has been in business, the more honorable the staff is likely to be. Magazines survive based on their goodwill with contributors. A publication that has had a dishonorable editorial staff (late payments, no payments when promised, lower rates than promised, etc.) is not going to stay in business very long, so the older a publication happens to be,

the better your chances of being treated fairly. *National Wildlife,* for example, was established in 1963.

According to the back issue of *Photographer's Market, National Wildlife* is: "For environmental activists, hunters, fishermen, and armchair travelers; 'our readers are concerned about man's environment, and they appreciate the drama and beauty of all wildlife, both plant and animal.' " The quote states that over 200 photographs are bought each year for one time use. It also says, "Query with resume of credits, story ideas, or samples, or send photos for consideration." In other words, if you have a single picture you feel is appropriate, you could send it. If you had just an idea for a photo story, that would also be acceptable.

Under "Subject Need," *Photographer's Market* reports that *National Wildlife* seeks pictures of: "Flowers; plant life; scenics; animals (mammals, birds, fish, reptiles, insects—action shots, close-ups, sequence shots, complete picture stories dealing with one species and single dramatic shots for covers); man and how he lives (environmental issues, people profiles, and photos dealing with backpacking, camping, canoeing, and hiking)." These pictures should either be black-and-white 8 x 10 glossies or color transparencies in sizes ranging from 35mm to 4 x 5. Any of the three formats are acceptable.

Finally, under "Tips," there is a quote stating that *National Wildlife* wants certain specific appeals. An editorial spokesman relates: "We urge the photographer to think editorially— although single photos are always needed for covers and inside use to illustrate a certain percentage of articles, we want the photographer's ideas on 'packaging' his photos into a feature that will give the reader a different way of seeing a familiar or not so familiar place, or some aspect of wildlife.' Also, 'we are always looking for that distinctive single photo . . . the sprightly, dramatic, colorful, human interest photo that lends itself to an accompanying short story.' "

Another magazine is *Runner's World,* which was founded in 1966. Again according to *Photographer's Market,* the publication emphasized long-distance running. "Photos purchased

with or without accompanying ms. Buys thirty photos/issue. Credit line given depending on where photos are used. Pays on publication. Buys all rights, but may reassign to photographer after publication. Query with samples. SASE [Self-Addressed Stamped Envelope—explained in a later chapter]. 'Mark every picture with your name and address on back. It's incredible the number of people who do not do this and then complain when we can't locate their photos.' Previously published work OK 'if so noted.' "

Under the section marked "Subject Needs" the magazine states that: "We will look at anything that covers the subject of running." Then, under "Tips," the editor adds: "View running from a fresh angle. No photographer we know has consistently captured the sport, so there is a lot of virgin territory to be explored. Our magazine also publishes two other magazines (a quarterly and a biweekly) that can use some material we cannot."

Keep in mind that the information quoted may be outdated, and you should study the magazines or check the current volume of *Photographer's Market*. The reason for quoting this material is to give you an idea of the type of thorough information provided by this book as well as the other two volumes mentioned. They can be excellent aids in planning your attempts at marketing your photographs so that you reduce the chance of sending them to someone who is not receptive.

Understanding the needs of book publishers is somewhat more difficult. Books are often planned as much as two years in advance. The books on the stands at the moment may have no connection with the publishing company's current plans and needs. For example, one of my publishers made a major switch in emphasis. Instead of publishing books in the fields of psychology, biography, and conservative politics, as had been the case for many years, the publisher suddenly decided to bring out a specialty line of sports books. The publisher went from having little interest in photography to having an intense need for sports photographs related to the titles being introduced.

One approach to selling book publishers is to write to the publisher of each company, offering work on speculation. The mechanics of approaching publishers for all types of picture sales will be covered in a later chapter. However, basically you will be asked to send either a range of 8 x 10 samples forming a portfolio or just contact sheets to show how you work.

A second approach is to narrow your choice of contacts according to current releases. You can learn what books publishers are bringing out during the current year by checking a trade journal known as *Publishers Weekly*. This is the magazine devoted to the entire book business. It is read by publishers, librarians, book store owners, and others involved in book retailing. Publishers advertise forthcoming releases on the pages of the publication, with special issues appearing throughout the year announcing major releases of children's books, religious books, spring selections, and others. In the spring and in the fall the magazine looks like a miniature telephone directory. This is when the bulk of the books for the coming year come out. Thousands of titles are listed by the majority of publishers around the country. You can read these and see what types of books are coming out in the next few months; you can find out whether or not they are illustrated and might relate to work you can do. For example, some publishers may be bringing forth a series of how-to books for which pictures of architecture, models, underwater images, macrophotos, or night photography will be needed. Other publishers may be bringing forth books that are a series of photographs based around a particular theme such as women, the circus, dance, or even urban studies.

Reading *Publishers Weekly* will also acquaint you with publishers specializing in photography or planning such a specialized line. Such listings can also be found in the various market guides mentioned, but these guides will not list the latest releases. Those are found in the advertisements located in *Publishers Weekly*.

The problem with the book market is that decisions are made slowly. It is not unusual for a project to take two or three months in the planning, and I have been involved with

photography books that have actually taken a year in planning and more than two years in production. Photographs submitted during the earliest planning stages were often needed on file during the entire period of the development of the book. The actual selection occurred at the end of this time when hundreds of photographs were studied, then edited down to those needed.

Because of the slowness of book work, you should never submit irreplaceable images you think you can sell elsewhere. Generally, books will not buy exclusive rights to your work. Rather, the publishers will be buying the right to use the work in the book alone, leaving you free to sell the same images to magazines and newspapers. Thus you are in the bind of knowing that leaving work on file with a publisher may cost you money while not leaving it will prevent its consideration for the book.

The answer to this dilemma is to make duplicates. You can have a slide copied or an internegative or a color separation negative made, depending upon the value of the piece of work. There is no problem with black-and-white, of course, because you are selling prints made from a negative.

Slide duplication varies with the laboratory utilized. Labs working mainly for professionals are extremely careful with each duplication, even when they are done by machine rather than hand. Labs that are basically oriented for amateurs are often less quality conscious and may return duplicates that do not match the original closely. Since the quality of reproduction is determined by the quality of the duplicate slide you might send to the publication, your choice of lab is a serious matter.

Professional-quality labs providing careful slide duplication at reasonable cost are fairly easy to find, though you probably will not find one locally. Most of them advertise in publications such as *The Rangefinder* magazine, *Studio Photography,* and similar professional journals. You can find the full listing in the back of this book. However, just because they advertise does not mean they are any good. It is important for you first

to place two or three trial orders with any lab you are considering. This will give you a chance to compare the color quality of the original and duplicates. Then you can send the slides you want duplicated to the best lab.

Technically there is probably no difference between the professional lab you use and the lab handling your work when you take it to a drugstore for processing. The lab may be identical, in which case, the professional side will just be a separate division that offers hand work and other custom services. The people who work there will usually be more highly skilled than the ones who operate the amateur services. Prices will be higher and services be more extensive in the professional section. A lab that works only for amateurs will not be able to offer custom work, though in many cases, their normal services have excellent quality.

Slides should be duplicated the same size. Some labs only offer 35mm duplicates, which can result in poor quality when you start with a roll film original.

The price for a duplicate will vary from around fifty cents to several dollars each. In theory there is a difference in quality but, in practice, this may not be the case, something you can determine with a simple test. Hold both the original and duplicate to the light and study them. Does one seem over or under exposed compared with the other? Does one seem to have more detail or better color saturation? I always start with the cheapest duplicates I can get, checking the work of several labs with the same test slides. Then I either upgrade the duplicate service I order, paying more per slide because none of the labs did a decent job with their lowest priced offering, or I order from the lab that performed satisfactorily if one did.

In some cases the film used for slide duplication is better than the original. When Kodak first introduced Ektachrome E-6 films for daylight use, the color chemistry was such that the film was only certain to last a minimum of five years in storage. This compared to a minimum of fifty years with the Kodachrome film line. However, the slide duplicating film, also an Ektachrome E-6 type, had a superior chemistry to

regular Ektachrome for long term storage and an expected minimum life of twenty years. Thus the duplicate slides are more likely to be usable for many more years in the future than Ektachrome originals if they are handled correctly.

Slide storage is covered in depth in a later chapter as this is crucial when you are taking images with sales appeal that might last for several years. However, it is important to note that slides deteriorate when exposed to intense light and heat. This means that they should either not be projected or projected as little as possible. The use of a hand viewer with battery operated light or a light box with magnifier is preferable. You can also have duplicates made and project the duplicates.

Duplicate slides can be good insurance in case your originals are lost in the mails, though this rarely happens. Contrary to many complaints, few photographers ever experience the loss of film and/or slides when sending them through the mail properly packaged.

A second approach to insuring that your work stays safe is through the use of what is known as an internegative. This is a photograph of the slide that results in a negative. Both a print and a second slide can be made from an internegative, which acts exactly like the negative made from negative color film. However, it is made from the slide, not the original subject, which means that it can be of reduced quality.

Internegatives do not have extremely long lives. At this writing, internegatives may not have a storage life as long as that of a duplicate slide made with the E-6 chemistry Ektachrome. They also add an extra step when you need a new transparency, and this can further reduce the reproduction quality of your work. If reproduction quality is reduced enough, you can lose your sales value.

If you choose to use an internegative as a way of insuring the preservation of your original slide, obtain an oversized internegative when possible. I prefer to use 4 x 5 internegatives for 35mm and roll film duplication. This is more

expensive than the usual 35mm internegative, but I have found that final reproduction is improved this way.

The third approach to duplicating your slide is with what is known as a color separation negative. This is actually a trio of black-and-white negatives exposed through colored filters. Three separate images of your slide are taken, each through a different filter. When the black-and-white negatives are then used to create either a new slide or a print, the light passes through the same filters and a full color image emerges. It sounds amazing, but it is a proven technique. More important, using black-and-white negatives means that the image can be preserved for a century or longer. Your descendants several generations from now will be able to make a print or slide from the negatives, and the color will be as vibrant as you witnessed with the original. Unfortunately, this is extremely expensive and is a process you should save for images with great market value.

The overseas market is almost identical to that found in the United States, with the exception of glamour photography. European publications, especially those based in England, are extremely liberal in the types of images they will publish. Nude and seminude images are in greater demand for what, in the United States, would be conservative publications. For example, at this writing, *Stern* magazine, the German picture magazine which might be considered the equivalent of *Life* magazine, has been criticized for using so much nudity. Yet similar images never would have been published in this country.

The one advantage you have when presenting your work to the overseas markets is that you are exotic by virtue of your being from several thousand miles away. What is commonplace to you might be strange and exotic to someone in India, France, or almost anywhere else. Photos of a neighborhood street carnival may never rate a second look in your home town newspaper's editor or even from a national magazine. But those same photos may be extremely interesting to some-

one whose culture is slightly different. This is the same reason why photos of commonplace events in foreign lands rate so much space in many American journals. All that matters is that you understand how to determine the type of images you can take for sale and their potential appeal to editors, a subject covered in the next chapter. Then you can begin trying to market your current work as well as seeking freelance assignments if you so choose.

4

Determining Photo Sales Appeal

Many photographers enter freelancing with the attitude that they want to get as much as possible for their work. This is understandable. However, successful freelancing requires you to reverse your thinking process. Instead of saying, "What can I get from the magazine," you must start asking yourself, "What can I give to the magazine's readers?" It is only when you are thinking of the person viewing your pictures, not your pocketbook, that you can become successful.

Freelancing provides a very disproportionate income. Full-time freelancers find that they either starve or earn more than the average person. Individuals who sell only an occasional photograph find that the money received for that print(s) is usually greater than they would normally earn for other money-making endeavors taking equal time and expense.

Before you send any photographs anywhere, think about the work you want to offer. Why will the viewer be interested in it? Will the work entertain? Inform? Amuse? Grab the eye as a

cover must do? Be a pleasant artistic experience? Or are you reading more into your work than is there?

For example, suppose you go on vacation to New York City. You photograph your spouse standing in front of the World Trade Center. You photograph the Rockettes with a normal lens from the last row of Radio City Music Hall. You take a picture of Central Park from your hotel room six blocks away. You record the very top of the Guggenheim Museum, perhaps isolating your spouse and a statue currently on display. Then you return to the small, midwestern town where you live and want to sell the pictures to the travel editor of your local newspaper. You know that many people in your community are interested in New York, and you can't understand why the editor is so opposed to using your pictures. What you fail to realize is that you are not offering the images you think you are trying to sell. You are offering a memory, not the visual reality.

To understand what I mean about your reading more into your work than is there, let us analyze each of the pictures you brought back from New York as described in the previous paragraph. The first is the picture of your spouse in front of the World Trade Center. There he or she is, standing smiling and perhaps looking up at the giant structures to indicate they are very big. The reality is an image of a person in front of a doorway with a sign telling what he or she is seeing. In your head, you are remembering the fascinating restaurant at the top where you ate. You are remembering the breathtaking view of the city by night. You are remembering the rapid ascent in the elevator. You are remembering detailed experiences that filled you with joy. You are adding mental elements that do not exist in the actual picture. All you are showing your viewer is a person and a door. The viewer is unable to unlock the memories in your head.

The second picture is of the Rockettes, the precision dance team that has been thrilling both New Yorkers and visitors to Manhattan for many years. This is like the theater photograph discussed earlier. You were too far away to obtain anything

reproduceable in a limited space. The dancers will appear to be ants and the entire image will be useless to the paper.

However, you will be remembering the excitement of the events, the colorful costumes, the pleasure of the music, and the enjoyment of the movie that accompanied the stage show.

Next is the picture of Central Park from your hotel room. Because of the distance, all that you caught were other buildings and the tops of trees. The image might be magnificent, but it provides no information concerning the park itself. Yet in your mind, you're remembering the enjoyment of riding through the park in a horse drawn carriage. You're remembering the winding lakes, the children sailing toy boats, the romantic walk after dark between the park and your hotel, and the feelings of standing in the beautiful suite, looking out with your camera. Again the reality of the image and the memory filling in the visual gaps are quite different.

Finally there is the photograph of your spouse and the statue at the top of the Guggenheim Museum. The Guggenheim was designed by architect Frank Lloyd Wright after a period of severe depression when he felt he couldn't create effectively again. He considered the structure a second chance at creative growth and used a spiraling conch shell design. The interior is wide at the bottom, endlessly winding to a peak, making it the ideal structure for wide angle photography. A fisheye lens or fisheye attachment is perfect here, though all manner of wide angle lenses can be used. To isolate so narrow a segment of the museum as the statue is to reveal nothing of the unique visual character of the place. Yet in your mind's eye, when you looked at the picture of your spouse and the statue, you were remembering the spiraling ramp, the greenery at the bottom, and the skylight at the top.

How would you have taken those same pictures to ensure their use by the travel editor? The World Trade Center would have been recorded from as many angles as possible outside, even from across the street for a better vantage point. You might have gone so far as to lie down on the sidewalk and

photograph looking straight up if you thought you could keep from being trampled.

Next you would have gone inside and recorded shops, people, and anything else of interest. Finally, you might have ended with Windows on the World Restaurant located at the top. You would have recorded diners and the view, both day and night. The images could easily have been taken with available light and high speed film.

The Rockettes required your moving closer and/or using a telephoto lens. You might have gotten permission to work from the wings if you wrote the management in advance and explained you were a freelance photographer taking the pictures for newspaper travel page use. You might also have moved down the aisles from time to time, taking one picture and moving back to ensure no one complained about your blocking the way of others.

Central Park could have been photographed any number of ways. You could work from the outside at night, photographing the well-lighted street scenes. You could photograph the horse drawn carriages and then the scenes you encounter as you ride with the carriages through the park.

Next you might go through the park, photographing people at play, children on swings, the zoo, and other activities. There would also be scenic images of the lake, boaters, the wildlife preserve area, and all the other sections of this famous location.

Finally, the Guggenheim Museum would have been recorded with an eye toward showing off the architecture. A normal lens could get you interesting images by looking straight up from ground level or straight down from the top of the spiral. You could also show sections of the architecture from across the way. These images would naturally be enhanced with a wide angle lens, but it is not essential.

Once you have an assortment of these New York photographs, you are ready to take the now salable images to that same editor. Suddenly, you have a photo feature that tells a story in an exciting manner to be shared with everyone who

views the images. You have visually supplied the details of your trip while before they were only in your head. Naturally, you should submit black-and-white prints or both black-and-white and color slides since newspapers are usually able to print only the black-and-white. You could even leave the pictures in the form of contact sheets, making only a token number of 8 x 10 prints to show the editor.

The first step toward freelancing is to study your photograph files. Look at all the slides and prints you have retained and see exactly what you have. Earlier I stressed that color prints are meaningless for most freelance work because publishers do not want to reproduce them. However, study the prints and the color negatives you have not had printed to see if there are images that would be salable in black-and-white. Color negatives can be printed black-and-white so any image still interesting without the color is worth printing.

Remember that color negatives can be made into contact sheets through a custom color lab's services. (Many black-and-white labs carry the paper needed to print color negatives as black-and-white.) These sheets can be made in color, though it is less expensive to have them printed in black-and-white. Contact sheets are always cheaper than individual prints made from each negative.

Separate your images in any manner that seems appropriate. Some of the pictures might be general scenics. Other images will relate to a specific community. Still others night be street scenes, pictures of the elderly or almost anything else. You want to isolate the different possibilities for resale, something quite different from the filing techniques discussed earlier.

Now consider what you have. Can you put together a group of images which visually tell a story. If you want to sell pictures you took in a foreign country, what part of that country's existence will your photographs share with the viewers? Random photographs of major tourist attractions might best be sold through a stock agency that can pool your images with those of other photographers, selling them individually or creating a photo story from their files. On the

other hand, specific photographs presenting an in-depth look at a market in Calcutta, or a series relating to not only the changing of the guard at Buckingham Palace but also how the guards train and live in their barracks, would be marketable on its own.

An example of this situation might be if I toured my home state of Arizona. I could travel to the Grand Canyon and take extensive photos, selling an article to an overseas travel magazine or some other publication. I could take pictures at Old Tucson, the movie location twelve miles outside the city of Tucson, providing an insider's glimpse of both the film industry and the amusement-park aspect of the area. I could go to Phoenix and do an article on urban development in the sunbelt region. Or I might go down to Nogales, Arizona, and do a story on life in a border town or the problem of illegal aliens. I might even do a story on professional rodeo or a specific rodeo rider. Each story could stand alone and would have a market. However, none of the images, taken by themselves, would relate to the state as a whole. They are all just aspects of the land and would have to be sold that way.

If you have an in-depth series of pictures on a subject, you can then consider the possibility of marketing it either in the United States or abroad. Most United States publications have extensive photographs relating to the major cities such as Chicago, New York, Los Angeles, and Atlanta. Those who do not maintain files know sources for such pictures when they need them. They are likely to buy freelance work only when you have something truly unusual, such as the prismatic pictures photojournalist David Douglas Duncan took of major cities, or when you have photographed something so new that it is not on file. For example, if you photograph an international trade center being built in Kansas City, your images of the construction and early occupants may be highly salable. It will not have been in existence long enough for others to have recorded it extensively.

Generally, the competent professional quality photographs of well-known locations are best sold abroad. This is because

European and Asian magazines do not maintain large files of such images. What they have on hand will be left over from earlier stories they have purchased. Your work becomes of greater importance.

There are two ways to approach any publisher with a picture series. The less successful approach will be thoroughness of coverage with a lack of direction. For example, I have extensive New York scenes on file, more than enough to illustrate any number of general travel articles. If a publication is planning an article on that city and does not want material taken to order, it might be interested in looking at my images on speculation. The entire series will be purchased if it is appropriate or individual images might be requested. However, I'm taking a chance and may have my work rejected simply because it does not fit with present plans.

The preferable approach is to offer photographs built around a story that is complete in itself. A photo series showing the changing skyline of New York over the past six months, Central Park's attractions (the zoo, free concerts, Shakespearian productions, picnic areas, etc.), or perhaps images of the interiors of apartments owned by United Nations' diplomats would all be specific stories of interest. These are complete picture and text stories that would interest travel magazines, publications devoted to architecture and interior design, or even general interest magazines. The series of photographs of the homes of United Nations' diplomats might even appeal to some American publications as well.

It is possible that a careful review of your images on file will show that you have less salable material than you thought, at least in terms of complete stories. What you are likely to have are some beautiful scenic photographs taken anywhere—from your own backyard to some exotic island where you vacationed five years ago. You will have some nice pet photos, adorable children at play, perhaps images of unusual buildings, and interesting street scenes. Every photograph you are thinking of selling has strong visual appeal but does not particularly relate to any other pictures. These can be

sold to magazines buying such pictures, like regional magazines. They can also be sent to book publishers, stock photo agencies, and calendar companies. However, the pay may be lower than for an offering of a cohesive photo story.

Planning the Photo Story

You have gone through your files, analyzed your images, and come to the conclusion that you actually have less potential for sale than you thought. Yet you want to freelance, and you would like to begin marketing your work. The answer is to begin taking pictures specifically with resale in mind.

It is important to note that you do not have to be a professional photographer to freelance. You do not have to currently earn your living with your camera in any manner. You do not even have to be in a position to quit your job or take time off from work. You can work freelancing into your regular schedule, taking pictures for money in your spare time. You will probably not be able to compete with staff photographers of major news magazines or similar professionals, but you will be able to earn an income.

The first photography story you take as a freelancer will probably have to be on speculation. This can be done by taking the pictures and hoping for the best or by querying the publisher and asking if he or she would be interested.

Whenever you write to the editor of a magazine, you must provide enough information for the person to know whether or not the material might fit the reader's interest. It is one thing to send pictures of naked women to *Playboy* and quite another to try selling a feature story to the new *Saturday Evening Post*. The first can be done directly and will either be accepted or rejected according to the quality of the work, appearance of the models, and similar criteria. The second will be determined in part by the publication's audience.

For example, I live in Tucson, Arizona, a city that serves as the base for my photography. On the west side of the city, a wealthy businessman built a castle, complete with throne

room, draw bridge, and very dry moat. The idea of a castle on the desert is so incongruous that I knew there would be strong interest in photographs of the place. However, before spending the time and money to photograph the castle, I decided to contact a few publications.

I really didn't know which market to turn to to be certain of making a sale in this country. There were any number of possibilities, both with general interest magazines and newspaper supplements in the city where the builder came from. However, I decided to try abroad, thinking that a publication in a country such as England might enjoy such a photo spread. After all, England was famous for its castles, and a castle in the desert would seem rather incongruous to a reader in that part of the world. Thus, I contacted *Tidbits*, a weekly London tabloid along the lines of the *National Enquirer* or the *National Star*.

When contacting a publication, I never write to the editor by name unless I have had dealings with that person and know he or she is still there. I also never write the once standard "Dear Sir" because it is considered sexist by many. Instead I write "Dear Editor." Then I use my opening paragraph to try to excite the editor's interest in the subject I am offering. In the case of the castle on the desert, I might have written something to the effect:

> The moat is dry and the dragon has apparently gone to an air conditioned bar to escape Tucson, Arizona's, searing 100-degree summer heat. But everything else about the castle in the desert is authentic, right down to the throne room containing both genuine medieval weapons and modern rubber versions donated by movie companies involved with the structure.
>
> Would you be interested in seeing a photo story on Tucson's castle in the desert, a castle built by William Brady, a retired businessman, who spent almost a million dollars constructing his fantasy in the midst of cactus and tumbleweed? The photographs will be sent on speculation.

The reason for stressing that the photographs will be sent on speculation is to show you are a professional freelancer.

When an editor receives a query letter, he or she will look for the mention of the word *speculation* or its equivalent. This is because too many freelancers assume that a go ahead for a picture story means automatic payment. However, you are an unknown entity to the editor. Although the idea you have proposed might be perfect, your work might not. You might just make a minor error, such as sending color prints when either slides or black-and-white prints are needed. Or you might send the wrong size black-and-white, providing images smaller than 8 x 10 when the editor needs the full size print. Your work might also be just plain bad. There is even a chance that a similar story idea was submitted, and the editor will only use the one on hand unless yours is radically different. The editor wants to see the work but cannot be certain it will be purchased.

The words *on speculation* in your letter indicate that you are aware of the editor's potential problems. You are saying, in effect, that you will send the pictures and caption material without expecting a positive response. You will not yell, scream, bring a lawsuit, or otherwise carry on when the pictures come back because they are not what the editor is after. You will not send nasty letters, make angry telephone calls, or even bill the publication for whatever sums you think you should have received. These are all experiences editors have had with nonprofessional freelance photographers.

When you do not use the words on speculation, many editors will automatically reject your idea rather than asking to see your photographs. They are afraid that you will have an exaggerated idea of your images' importance and become extremely angry if the pictures are not used. They prefer not to get involved at all rather than face the irrational tirade of the photographer. Since it is important for you to try to get your photographs to the editor, because only in this way can the editor give you proper consideration, then you should use the professional approach by saying the work will be sent on speculation.

The third paragraph would identify you. You can write

something as simple as: "I am a professional photographer." Or you can take your description a step further and add relevant information such as: "I am a professional photographer who runs a commercial studio." (Or works for a newspaper or has worked for magazines or whatever is appropriate.) However, if you have no background in the field, *still state* that *you are a professional.*

"Isn't this lying?" you may ask. "Isn't it wrong for me to state I am a professional when I have never sold a picture in my life?"

The answer is that there is no right or wrong answer. An amateur, technically, is someone who does something for the love of it. This is the origin of the word. A professional gets paid for what he or she does. I earn an excellent living from my work and consider myself an amateur. The word is used because of intent.

There is another advantage to using the word *professional* in reference to yourself. I have had editors write to me after they have decided to use my work and say something to the effect: "We normally don't pay for photographs purchased by themselves. But we noticed that you said in your letter you are a professional, so we will pay a token fee per print of $10" (or $25, $50, or anything else that fits the magazine's budget). Thus, it is in your best interest to use the word professional.

I realize that when you first start out in this field, you are anxious to get your work published regardless of whether or not you are paid. However, if your work is worth publishing, it is also worth money. This may only be a few dollars for one publication or several hundred for another. Whatever the case with the particular magazine, if your photographs are worth printing, they are worth your receiving the standard fee.

Finally, I sign my name, address, and telephone number. Then I enclose a self-addressed, stamped envelope for the editor's reply. Publishing costs have risen to such a degree that the only way you can be certain of having an editor reply, even when work is desired, is by including a self-addressed, stamped envelope (sometimes called an SASE when you read

about freelancing in market guides). When you eventually send photographs to the publications, you will also need a proper sized envelope and postage for their return.

Once I have the go ahead, I contact whoever is involved with the subject of my planned photo stories. Most people are delighted to have you photograph them or their business, home, or whatever. Others want to be certain you are on assignment for a magazine before they say it is all right. Unfortunately, you frequently cannot legitimately say you are on assignment nor can you explain what it means to be working on speculation.

My answer to this dilemma is to try getting in to photograph regardless of the person's hostility. I do this by stating the truth in a manner that I know will be misconstrued. For example, suppose I want to photograph Wilhemina's Girdle Factory, and *Girdle Business* magazine has told me that they will look at a photo story on the company's new castiron girdle maker, but only *on speculation*. They are not certain they can use my pictures, but they want to look at them since the subject is of reader interest. I call the company, and the conversation goes something like the following:

"Good morning. Wilhemina's Girdle Factory. Our girdles stretch to fit even the biggest lardos. Can I help you?"

"This is Ted Schwarz. I'm a professional photographer who wants to come out and photograph your new girdle maker for *Girdle Business* magazine. I wonder when that might be possible."

"Are you on *assignment* for the magazine?"

"I'm taking photographs for the editor. The decision concerning a full photo feature will not be made until after they have been reviewed."

"Well, since you're on assignment, how about coming out a week from Tuesday at 9 A.M.?"

Notice that never once did I say I was on assignment. Everything I say is the truth, but my wording is deliberately ambiguous. I am taking pictures for the editor because that is the person who will review them. Since I am working on

speculation, a term I omitted in my telephone conversation, the decision concerning publication will not be made until the prints are reviewed. This is all true. However, the implication to someone who has not listened closely to what I am saying is that the material is being prepared on assignment. In more than twenty years of freelancing, no one has ever asked me about the assignment a second time. My answer suffices, even though I have not said what they think I said. If they did ask again, I would be completely truthful. However, the first time I am asked, I find I get much further by replying in a manner that is honest yet ambiguous.

When I go to the location where I will be taking photographs, I try to travel prepared for anything. I take all the *relevant* equipment I own. (An extreme telephoto has little or no value in a factory, and an ultra-wide-angle lens probably is of no value taking nature studies of birds.) I also take along extra lighting. Depending upon the type of place I am going to, this might mean electronic flash, floodlights, or a lot of prayers.

Ideally, you should have two of everything critical, such as camera bodies, so you have a back-up. Unfortunately, most beginning freelancers are underequipped and have to get along as best they can. This is especially true with electronic flash units. However, at least make the purchase of three flash cords for connecting your flash to your camera. A flash cord will always break when you need it unless you have a spare. However, if you have just one spare, that cord may commit suicide or run off to wherever such cords go so that you are without it at the crucial time. Carrying three cords makes the first cord so nervous that it works perfectly, knowing it can be replaced by not one but two cords.

Flash-connecting cords are the least expensive equipment; yet they can make or break an assignment since they are the key to your using extra light. It is better to own several since they are so poorly made.

I usually pack my gadget bag with those items I am certain to need, then leave the rest locked in the trunk of my car. I

might carry a tripod or unipod, inexpensive flood lights, extension cords, and gaffer tape (also sold as duct tape) for attaching a light to the wall without risking plaster or wallpaper damage.

The amount of film you carry can be critical to the success of the photo story you want to sell. Film is the cheapest aspect of the freelancer's work. If you have never taken pictures specifically for sale before, you may have a tendency to carry film on your first professional job the way you did as a casual picture taker. Remember that you need the highest quality images possible, and you must take them regardless of the conditions you encounter. You should also realize that even professionals have very few top quality frames per contact sheet or roll of slides. There will be any number of near misses edited before the work is submitted to the editor.

I like to take more film than I can possibly use for each assignment and also take a variety to cover every possible contingency. In some cases, the film you plan to use will be dictated by what you photograph. For example, when I photograph in a nightclub, I automatically assume I will need high speed film. I carry ASA 400 black-and-white film and ASA 400 color slide film, then use labs that will push process it as far as necessary. Usually I keep the color to a maximum of ASA 800 because I do not like the color shifts that come when the film speed is more than doubled. However, this often means using a tripod and a shutter speed so slow that I have to concern myself with peak action and check each slide for objectionable blurring. The black-and-white might be exposed as high as ASA 3,200, as has happened in a club where the spotlight offered little more illumination than a bathroom night light. Thus, at this writing, Tri-X and Ektachrome 400 are my staples for such projects. If new films are introduced at this speed or somewhat faster, though without increased grain, then that is what I will use.

How many rolls will I take with me? Usually I will take a minimum of six thirty-six-exposure rolls of 35mm film of each type and I prefer to take ten if my budget allows. When I

must skimp on the number of rolls, I will usually cut back on the color since there are fewer publications interested in color. This can be false economy, of course, because I have more discards with my color work since the slower shutter speed increases the chance for blurring.

With 120 film I will take at least ten rolls of color and black-and-white film and have often taken twenty rolls of black-and-white. The only time I find the larger format essential is when I know I am either going to need extreme enlargements or will have to crop greatly because I cannot get the vantage point I need to be effective with the lenses I own. The 120 negative is more than four times the area of the 35mm negative, so an 8 x 10 enlargement is actually one-fourth the blow-up with full frame 120. Very seldom do I really need both formats, though, and I rely on the 35mm for most of my work.

An afternoon sports event is quite different. I might take a slow speed, fine grain color film such as Kodachrome, as well as the somewhat faster Ektachromes. Black-and-white film will be a fine grain, medium speed type such as Plus-X. Again, I will take several rolls more than I think I will need, especially if there is a lot of action. I do not use a motor drive or power winder for such work but may click off three to five frames per play during an exciting moment of a baseball or football game. Thus, I could quickly go through my rolls.

Outdoor sporting events should photograph perfectly with the films mentioned, but I always cover myself with a few rolls of high speed film, at least in black-and-white. This ensures that I will be able to take pictures if the day becomes overcast or if I need an extremely fast shutter speed for something. I can also increase my depth of field with the higher speed film, something that might be necessary when using an extreme telephoto (400mm and longer, as well as a shorter telephoto coupled with telextender).

The basic rule to follow is to plan carefully for whatever you are going to record. Take more film than you are certain you will need, then add special film for unexpected emergen-

cies. I will even go so far as to take both daylight and tungsten film to stage shows in case I discover the lighting is wrong for what I thought I would encounter.

Here's a tip for stage shows. When in doubt, use daylight film. Daylight film exposed to tungsten light sources will have a reddish cast. Tungsten film exposed to daylight sources, such as carbon arcs, will have a bluish cast. The reddish cast is acceptable as a flesh tone. The blue makes the people look sick. If you can only take one film indoors, make it a daylight type.

Sometimes you know that the pictures you are taking are going to have broader appeal than just the publication you have in mind. When this occurs, try to cover yourself by taking more images than you need. Use both black-and-white and color. If you have cameras using different formats, such as a 120 format and a 35mm SLR, take both along and take pictures with each, assuming there is time. The extra work will go into your file and can satisfy a different publication's needs.

Always analyze what you are taking in light of the different possible markets. For example, suppose you are photographing a sports event such as a baseball game. The pictures are going to be used in a sports magazine that is doing a story on that particular team or perhaps on the rival team and its opponent on that particular day. Overall pictures of the game and any special happenings, such as a fight on the field, will be of primary importance. However, stay alert for other possibilities.

Is there a bat boy working with the team? Photograph him and take a variety of images showing his duties and how he enjoys the game. These will be good photos for a teen magazine, especially when coupled with information on how such positions are filled. Many teens aspire to work on the fringes of a ball team, and your picture story of the bat boy will be in demand.

Is the bat boy a member of an organization such as the YMCA? If so, that organization's magazine, newsletter, or

bulletin might want one or more pictures for a brief photo story.

Is there a new player from another city? Photos of that player in action coupled with some statements from the manager, owner, and other players on his performance might sell to the sports page editor of his hometown paper.

What about a player who sustained an injury and is now back on the field when no one thought he would return. This story might be good for a general interest magazine, a religious publication, if his faith was a factor, or a magazine such as *Family Circle* if there is a tale of dramatic family interaction.

Does one of the ball players hold an interesting off-season job? The trade journal for that field will be interested in his story.

The ideas are endless if you take a lot of pictures and think creatively beyond your immediate needs. In fact, there is a chapter in this book devoted to possible photo stories in order to stimulate your imagination.

Remember that the more sales you can make from one photo session, the better. You are not selling the same images over and over again but using different photographs from the same picture taking session for your sales. This in no way affects your copyright.

Upon arriving wherever I am going to photograph, I report to whomever is in charge. Sometimes this is the public relations director or the construction crew foreman. Other times this might be the head of a company or organization. Still, other times you just report to a particular box office when you are going to photograph the game, stage show, or whatever.

How you work will be up to you. I always try to be as unobtrusive as possible. I photograph plays during dress rehearsals, night club acts during whatever night is the slowest, and athletic events from the sidelines using telephoto lenses. I try to carry equipment that is quiet and minimal for the job.

For example, when I photograph in clubs, I will always have a tripod with me and a unipod in the car. The tripod is set up after talking with the waitresses, waiters, and other staff. I make certain that I work where I can see clearly but will not interrupt their activities. I never carry a flash so long as there is an audience, though I have occasionally boosted the lighting slightly when it was under rheostat control.

If the best pictures are only possible by providing a certain amount of direction and changing of the way an activity goes on, such as when recording a play, then I try to arrange for a special picture session. At that session, I alter the director's blocking of the actors in order to make a tighter grouping more suitable for a newspaper photograph. This is essential for publicity pictures, but you will often have to work without this privilege for magazine illustration unrelated to the show's publicity.

A picture story involving a particular person must be done with that person's cooperation. Talk with the person, either the day you arrive or a day in advance. Explain how you will work, what you expect, and how you want the person to dress. My feeling is that the individual should dress normally, ignore me and go about his or her activities in the usual manner. If these are not visually interesting and I need to show a wider variety, we will usually try to rearrange the normal day's work enough to cover everything visual I need.

For example, when I photographed the formerly brain damaged girl in Scottsdale, Arizona, for *Family Circle*, I had to take pictures of her using a gym, running with her family, using her typewriter, doing homework, and working in a garden. All of these events take place every week of her life. However, she normally does not do all the things I recorded on the same day. We arranged everyone's schedule so she altered her routine and conducted a week's normal activities within the same twenty-four-hour period. This saved time for everyone, was not really dishonest, and ensured images that would not have been possible within that same time frame had we not discussed my needs a few days in advance.

Usually, I work with available light and high speed film. Flash, if essential, is softened by bouncing it from a white wall or ceiling. Often, when office lights are low, there is a rheostat that can be turned up. There may also be lights that have been turned off as an energy-saving factor. I check for such a situation, then turn on all the lights before taking pictures. However, when you are finished photographing in a particular area, turn off all the lights you added as a favor to the people involved.

Businesspeople who are tense can sometimes be relaxed by putting them into normal situations when taking their photographs. When I want a picture of a business executive talking on the telephone, but he or she obviously poses each time the receiver is held just for a photo, I ask the secretary to actually call the person from the other room. When the executive is talking to a real person on the other end of the line, he or she invariably relaxes. A doctor might be recorded taking the medical history of the office nurse. Give a person something familiar to do and that person will relax.

The same holds true for totally controlled situations. For example, suppose you do a picture story of a dancer and want to include one head-and-shoulders type portrait in addition to material taken on location in the theater, back stage, and in the rehearsal hall. The dancer has been totally ignoring your presence the entire time you have been working, and the images are excellent. However, then you take one picture isolating her against a curtain, in front of seamless background paper or near a white wall where you carefully focus for the portrait. Suddenly she is tense. Her mouth is tight, her eyes are slightly hard from nervousness, and she loses the attractive spontaneity that was so exciting about her. You know the portrait will detract from the other images because it shows a totally different individual without the loose casualness you recorded as she worked.

The answer is to have the dancer act naturally. Tell her you want to see her move through some dance positions while you focus only on her head. Ask her to stay in the same plane in

relation to your camera. Then focus on her face, using maximum depth of field since she will be moving somewhat. Your portrait photographs suddenly have the kind of life and attitude you need for an effective image. You will probably use far more frames than would otherwise be the case, but at least you will get what you are after, without the tension that was there before.

Children are usually the least self-conscious of all subjects. I find that for the first five or ten minutes that I am working around them, they are all over me. They want to touch my camera, look through the finder, and ask all sorts of questions. Then they become bored with my constant clicking, stop making funny faces, and begin to ignore my presence. They quickly become interested in their own games and activities, allowing me to work effectively. They become so absorbed in what they do that you can take close-ups with a normal lens and never have them give any indication that they are aware of the camera resting inches from their faces.

Finding ideas for photo stories often seems the hardest part of trying to freelance, and because of this I have included a chapter with literally hundreds of possibilities for you to try, regardless of where you live. Generally, you will find that all local stories can be nationalized and national stories can be localized. Thus, it becomes a matter of reading your daily or weekly newspaper with an eye toward what would be visually interesting to someone else.

For example, I read a wire service story about a woman living in the eastern part of the country who had been diabetic since she was a child. She remembered how hard it was for her to adjust to injecting herself with insulin as she grew up. She volunteered at an area hospital where she discovered that the same problem existed for children in her part of the country, and she realized it was probably a universal difficulty. She thought it would help if someone could invent a doll that could be used as a teaching tool by allowing the child to practice with it. The result was a doll, now being marketed nationwide, into which a child can inject either insulin or a similar liquid with a genuine needle and syringe.

The wire service story was short. There is a chance that a longer photo essay, showing the woman at home with her children, injecting herself with insulin and working with hospitalized children using her doll would sell to a national magazine. However, I do not live anywhere near the woman and did not think I could convince the editor of a national magazine to pay me enough money to take the pictures in that city.

The alternative would be to go to a local hospital and talk with the person who handles public relations. Find out what is being done locally to help children adjust to being diabetic and needing to take insulin. Possible photo stories would include how the children are taught to inject themselves, the story of just one child in the hospital, and also the day in the life of a diabetic child. The latter would show how the child must inject himself, as well as how the child goes about school, athletic events, interacting with friends, and engaging in other normal activities. One of the strongest appeals of any photo story on someone with a serious illness or other handicap is showing how much like everyone else the person functions. Your photo story will be strong if you can show people that the child is completely normal except for having to take insulin and watch his or her diet each day.

A local story might have national implications. For example, I once photographed a young woman who teaches gymnastics from her wheelchair. This story will have national appeal if I change it to a series of photographs of people with handicaps accomplishing unusual athletic activities. I would include the woman, a runner who has no legs about whom I once read, perhaps a handicapped hang glider pilot, and similar individuals.

The easiest way to locate unusual people is by checking human interest stories in out of town newspapers, weekly publications such as the *National Enquirer, Time,* and *Newsweek,* and by talking with various associations that might deal with them. Handicapped people accomplishing unusual tasks are well known to national associations dealing with people who share their illness or affliction. Most annual almanacs

such as the *World Almanac* have a list of associations that can lead to ideas. Your Yellow Pages and the Yellow Pages of major cities can also yield clues. Many public libraries maintain out-of-town directories, and you can also get them through your telephone company's business office.

To give you an idea of how I might work with a newspaper when trying to find photo story ideas, I will take my morning newspaper, which has a circulation somewhat in excess of 100,000. The major news stories are not important because they are the domain of the daily news photographers. However, everything else is fair game.

The front page of this newspaper mentioned that there was a jetliner hijacking on the West Coast, and inside is an item on the problems with air-traffic control at the local airstrip. Possible photo stories on a local basis would be on air safety at the airport. These might include security areas, fire fighting equipment and training, theft of personal belongings, and the use of small planes sharing the landing strips with large airplanes.

Another story mentions a scandal involving allegations of a prostitution ring and the involvement of the mayor. Why not take your camera and spend the night traveling with vice squad detectives? Or travel with a patrol car in a high crime area on a busy weekend.

An Associated Press photo shows a roller-skating stunt man at a California rink. Are there local performers who use skateboards or roller skates? That would be a good area photo story, and you might find there is national appeal, depending upon the background of the person involved.

A story on professional volleyball triggers the idea of a local picture story on girls involved with sports. Professional volleyball teams use men and women. What sort of local sports training can girls in your area receive? What are junior highs and high schools offering? What about area colleges and private athletic clubs? All of these are excellent visuals.

A two-hour drive from my home is a dental office run by a

group of retired dentists determined to bring quality care to low-income individuals. They are the only dentists offering care for the indigent in the center of more than 1,000,000 population. A photo story might be excellent for one of the dental trade journals.

A wire service article mentions the problem of shark attacks being less for people with some understanding of self-protection in the water. Do you live near the water? How about a how-to-do-it photo story with an expert diver showing how people can reduce the risk of being injured in the water. In my area, which is all desert, a similar story could be done built around swimming pool safety and sold to an area newspaper.

An article on a local artist who produces portraits despite being crippled and partially blind from multiple sclerosis is a good visual. Magazines for the elderly (he is over sixty-five), art journals, publications aimed at the handicapped, and similar markets are all logical ones for his activity.

Another story in the paper deals with a high school junior who became a solo pilot for the first time. Not only would this be a good photo story for national magazines relating to teens but also for an even broader market, because he is the fourth generation in his family to fly and all are alive.

The photo stories outlined are off the top of my head as I glance from page to page. They are not the result of careful reading and thinking, which undoubtedly would yield more. The reverse could be done, localizing national stories for sale to area newspapers, weekly publications, and city magazines. More important, you will find that with a little thought you can do this, too, keeping numerous ideas circulating at all times. You will obviously always have more potential work than you can handle.

Before going after any story, make certain you have the equipment to handle it. Photographs taken in a mine, for example, are going to require extensive lighting units. If you own a single electronic flash, you will be underequipped and

probably should best avoid such work. The same would be true if perspective control equipment was essential for an architecture story. However, these are the rare exceptions.

Finding photo stories you can take and sell is actually quite an easy task. All it takes is a little thinking while you read both local and national journals. Then twist the stories so they appeal to whatever markets you may have in mind. Such effort may seem like drudgery at first, but with a little practice you will discover that you always have far more salable ideas than time in which to take the images.

5

Writing Captions, the Law, and Other Essentials

Caption writing causes needless problems for a large number of photographers. The reality of captions, even if you are convinced you cannot write, is that they are simple to handle provided you make some advanced preparations.

First, always carry a small notebook and a pen in your gadget bag, pocket, or purse. This will enable you to record all the information necessary at the time you take a picture, assuming the details might not be available any other way.

For example, suppose you photograph small children in the park. You are doing a photo story on an area that had formerly been an industrial setting. An old manufacturing plant located on the site for fifty years built a modern facility several miles away, tore down the old building, and made the land into a community center. You are the person who is recording all this, and you will be selling pictures both locally and, hopefully, to one or more trade journals with a readership in the same business as the manufacturing plant.

The exact location of the manufacturing plant should be no problem for you. You knew the street address or you couldn't have found it. More specific details can be learned by calling the public relations department or the corporate offices of the manufacturer, as well as the city government offices. There is no reason you need to concern yourself with such information while you work since it can easily be obtained at a later time.

You arrive at the park and begin photographing. You take pictures of children on swings, couples strolling hand in hand across the grass, families enjoying a picnic, and dogs romping along the grounds. So long as the pictures are going to be used editorially, you do not need to have model releases. However, what happens later should there be photos you want to sell to the manufacturer to promote its civic mindedness? Or what if the editorial policy proves to be one where the pictures used with a story must have captions that include the names of people shown? This is often the case with limited circulation publications such as small town weeklies. The editors feel that printing names in captions encourages people to buy more papers, especially the family and friends of those shown in the pictures. If you just have been casually snapping images, what do you do when you are asked for identities for captions?

The answer is to take the photographs you need, then approach the people for their names and either their addresses or telephone numbers. Each roll of film can be numbered with an indelible pen. (Use it on the metal cassettes that hold 35mm film and the plastic cans that hold the film and/or the box in which each roll of 120 film comes.) You can also use self adhesive, numbered dots found in many stationery supply stores.

You generally will be working in fairly tight clusters as you photograph. Certainly, you will want panoramic views of the entire public parks, but none of these is likely to have anyone easily identified by looking at the reproduction in a newspaper, magazine, or other publication.

Other photos might involve some children at play, a family,

or other group. Take as many frames as you can, then make a note in your notebook as to who they are. Thus you might have a notation such as "Roll 1—Frames 17-25." This will be followed by the name and either telephone number or address of each person shown.

Always approach the people politely. Say why you are taking pictures and ask if you can have the proper spelling of the person's name for the captions. If they are angry with you for taking the pictures, make a note of that because you may not be able to use the frames or at least should think twice about it. So long as the pictures are used editorially and in no way libel the people shown, their refusal to have you use the pictures taken in a public park is not very meaningful. You could legally use the pictures anyway. However, it might still be prudent to back off and not use them under such circumstances.

Most people will provide their names and will at least give a business telephone number. If they only give their names, that is fine. Even if a couple just provide first names, you are fine. However, mention this fact in the caption material you send.

Ask children who are small where you can find their parents. If parents are not around, probably the children were brought by an older youth or an adult who is acting as babysitter. The parent, sitter, or other adult is the person to whom you should turn for the identification you need. This is for your own protection, as many people fear adults who talk with children. They may think that you are a child molester, even though your camera is quite obvious at all times.

Pets should also be identified for the caption, and you should know the owner's name as well. A pedigreed dog or cat is quite readily identifiable by an expert. If you later want to use the picture for advertising purposes, the same restrictions would apply for the pet as for a person. In fact, when I photographed a pedigreed dog playing with the model/owner around a lake, I had a separate release made for the dog. The dog's name was typed in, and the owner signed in the same

way that the parent of a child under the legal age would sign a release. Fortunately, I did not need to go so far as to get a paw print.

There are two different thoughts concerning the necessity and timing of obtaining model releases. One is that you should have a release the moment you take a picture. This insures that you will always have one. You will never have to track down the person later, and you will never have to worry about how a picture might be used. This is valid reasoning, and I can understand why photographers who freelance full time always carry releases with them. In fact, I also try to keep a package in my gadget bag, but I seldom use them that way and frequently forget I have them.

Why am I so casual in the use of releases? First, under most circumstances you can photograph anyone just about anywhere and use the pictures editorially. You can take pictures on city streets, in parks, and even in what might be considered semiprivate areas such as stadiums, race tracks, and the like. The major restrictions are mostly those of common sense. The pictures cannot hold the person shown to be ridiculous, actually a form of libel. You can also not take pictures under circumstances that might endanger the health or welfare of others.

For example, suppose a fire is being fought by firemen in a warehouse. You are standing on the street, and a policeman asks you to move. You explain that you are taking photographs and feel quite justified to do so. Yet the police officer says to move or be arrested. Do you have the right to stay there?

The answer is probably that you cannot stay by the fire scene when asked to move. You may be blocking essential equipment. You may be in danger of being hurt by an explosion and not even know it. There may be any number of problems that could jeopardize you, the firemen, or the people in the area, and the police officer doesn't have time to explain them. You have been asked to move, and that request by a law enforcement officer takes precedence over your right to stand there and keep taking pictures.

Sometimes there is concern that pictures taken during an emergency situation could result in the injury or death of the photographer. For example, suppose there is a fire in a building that contains explosive chemicals and you are standing in the street, several yards away. Your tendency would be to want to stay at that vantage point, knowing it is a good one, and resenting the order to move. What you can't possibly know is the potential force of that explosion should it take place.

I was in such a situation many years ago. I resented the order to move and kept trying to snap pictures. Finally, one of the firemen gently but firmly took my arm and physically moved me a hundred yards back. He said the potential for explosion was so great and the possible power of the blast so strong that I simply wasn't safe. I did not believe him until he returned to the exact same spot on his way back in to fight the fire. The chemicals inside ignited and the blast literally blew him apart. He had saved my life, and I had been stupid enough to think that someone was simply trying to keep me from getting a good picture.

At other times you will be asked to move because you lack proper credentials. Only working press photographers are allowed to be in certain areas at the scene of an emergency, a restriction you may resent. Your feelings will probably be that "the fix is in" and that the papers have somehow conspired to prevent freelance competition. However, the reality is quite different.

A working press photographer recognizes that his or her job contains an element of danger, especially when covering an emergency situation. The photographer has, in effect, agreed to hold everyone blameless if injury occurs while taking the photographs. The person accepts the risks when signing on with the paper, is protected through insurance and Workman's Compensation, and will not sue if injured while working. Thus, had a press photographer been the person killed at the scene of the fire, no lawsuit would have been filed by the family. The photographer took a calculated risk as part of the job and tragically lost the gamble. If someone not working

full time in the business was killed, the family would un-
doubtedly have sued the city, the place where the original
emergency took place, and anyone else because of failure to
protect the photographer. You are kept away from emergency
scenes to protect both your life and the various emergency
organizations that could be sued.

The only two answers to this problem are to obtain a press
pass or handle the matter at the scene of each emergency you
encounter. Most police act on their own best judgment and
allow photographers to remain in troubled areas unless the
sight of your equipment will cause more problems. If there is
an attempt to arrest someone, an angry crowd gathering, and
the potential for a riot, a photographer's flash or even the
visible camera could foment violence. However, at the scene of
an accident, if your presence isn't hindering any of the rescue
work, no one is likely to care about your camera.

Fires are quite different matters. Sometimes there is a clear
and present danger and other times you are just standing in
the wrong place. You are told to move when, in reality, if you
would just relocate slightly you would neither be in the way
nor would you be asked to move again. However, the only
way you will know this is to go to the person in charge.
There is always a captain, battalion chief, or similar fire
official in command who can tell you where to stand. Just be
certain you do not interrupt his or her giving orders to the
others in order to question where to go. In fact, while
standing by the person in charge waiting to ask where to go,
you might take photographs if the vantage point is good. The
person in charge generally stands in a relatively safe area, not
because it offers protection but rather to get an overview of all
that is happening.

There are two sources for obtaining press cards. One is
through any number of organizations that advertise in pho-
tography magazines and a few other publications. These are
supposed to be official, and they certainly look impressive to
the person unfamiliar with real cards. They have room for
your photograph in many cases, and they give the name of an

important sounding organization. But they are absolutely worthless.

Every community with a newspaper has a consistent method for providing identification to legitimate, working photojournalists. When I worked for a newspaper, we were given two types of identification. One was a card supplied by the newspaper that told where I worked and gave about as much background as my driver's license.

The second identification I carried was issued by the police department. It included a mug shot photo, fingerprints, and identification number which matched the records kept on me. That card could get me into every emergency situation in the city even though my press card, issued by the newspaper, was sometimes ignored.

Fortunately, there is seldom a reason why you will need press credentials while freelancing. You can usually work at an emergency scene without difficulty. However, if you feel you have a legitimate use for such identification, such as if you become a stringer for a newspaper, then you should go see the chief of police in your area. His or her office will be able to show you the proper way to get acceptable credentials if, in your community, they truly are necessary. Under no circumstances though, should you try to use credentials supplied by any outside organization, no matter how official they claim to be. They mark you as either an amateur or a fraud in the eyes of the police and fire department personnel and may get you evicted from an area faster than having no credentials at all.

An accident, fire or other scene of trauma and disaster can lead to exciting, dramatic images. How often over the years has your eye been arrested by the front page photograph of a couple weeping in each other's arms, a fireman clutching a small animal, a police officer desperately trying to revive a baby, or some other dramatically moving experience. These are commonplace at disasters and even someone with no news experience can have a fairly easy time recording great drama. However, this is not the time to ask for a model release to be

signed. The best you can hope to do is record the names of the victims in your notebook and often you will have to get these from the officers involved, not the victims.

Part of the caption material you will be expected to provide when selling spot news material of this type will be the results of what happens. It is not enough to learn that Denton J. Dingbat was transported to Bedpan General Hospital with suspected internal injuries after apparently being drunk and running his car off the road. You must call the hospital to find out the specific injuries and, if they will not tell you, check back with the traffic unit of the police for a report on those injuries. The fact that Dingbat was drinking adds to the caption, but a suspicion of this fact is not enough. You can only state that Dingbat ran off the road based on the facts gathered at the accident scene. You will need to call the police to learn if he was charged with Driving While under the Influence (DWI), the charge normally associated with any accident involving drugs or liquor.

Most hospitals and police departments have community relations personnel to act as the liason between the press and the public. These are the people you normally will contact to learn about the aftermath of an accident. However, often these people will not reveal information, or else they will spend so much time obtaining permission to do so that you have difficulty meeting your deadline. The answer is to call people more directly involved.

I try to contact emergency room nurses, record clerks, and doctors at hospitals. If the story warrants, I won't just call, I'll go to the emergency room and talk with people there. If you approach them nicely and make it clear that you're under time pressure, somebody will usually talk. You will not be referred to the public relations manager, who might feel a need to check with the family to see if that information can be given out.

Police and fire department officials can be reached just by getting names at the scene of the accident. If all else fails, call the traffic division, homicide division, arson squad, paramedic

unit, or whoever else might have information. Usually some-
one will tell you what you want to know.

The scene of a disaster or an accident is the place to get as
much information as you can, even if it is only to learn who
to contact (hospital, homicide squad, traffic division, etc.) later
that day. Then take your film to the newspaper where you
want to sell your photographs and call for additional informa-
tion from there. It may be that a reporter with existing
contacts, such as the police or city hall reporter, can find the
information faster than you can. If this is not the case, it
sounds better to be calling from a newspaper, especially if the
officials have to call you back.

The caption is basically nothing more than the classic *who,
how, what, when,* and *where.* The editor wants to see *who*
was involved, *how* the person(s) was involved, *what* happened,
when it happened, and *where* it happened. Dates are essential
though a daily newspaper will use the term *yesterday* or *early
this morning* due to the immediacy. If you are working for a
weekly or monthly publication, you will need to say, "Thurs-
day, July 17," or whatever is appropriate.

Be certain to cross-check an address if at all possible
whenever writing about a crime. Suppose you happen to be
near a tavern when there is a surprise police raid because the
back rooms are used for gambling and prostitution. Also
imagine that the name of the tavern is the "Do Drop Inn,"
owned by Gustaf Gambino. Quoting these facts is completely
legitimate, but you had better get all your facts straight.

The names "Do Drop Inn" or "Dew Drop Inn" were
extremely popular in the East and Midwest at one time. I can
remember working as a photographer in Cleveland and spot-
ting three different bars by that name, and, I suspect, a check
of the telephone book would have resulted in my finding
several others. Where I am living now, there are two different
bars called "Fred's" and bars called "Hair Tiz" and "Here
'Tis," the names of which could easily be confused by a copy
editor. It would be essential that you give the exact street
address of the bar in your caption under such circumstances.

The same is true for the owner of the bar. Many papers like to give the home address of anyone arrested in a gambling raid or for some other crime even though the violation occurred at the person's place of business. If you do not carefully check the name provided by the police, you might accidentally use the address of Gustaf Gambino who is a parish priest or Gustaf Gambino the president of Overdrawn Funds Bank and Trust, one of the most honest individuals in town. The use of the wrong address could be libelous and must be checked.

There are several ways to check on an individual's home listing when you need it. One is to use the telephone book, cross-check the address, and call the home. You would ask if this is the residence of Gustaf Gambino, the owner of Do Drop Inn on 34th Street. You could also use the City Directory, a copy of which is retained by most newspapers and almost all public libraries. This lists the name, address, and occupations of most people in the city. Not everyone is listed in the City Directory of each community, but most people are.

If all else fails, hedge on your information. Say something such as: "Police reports show the arrest of Gustaf Gambino whose address was reported to be 00098 Fransleigh." This information must be taken from the public arrest records maintained at the station. If the address is incorrect, you are at least quoting what should be a reliable source. If there is a problem, no one is going to be able to successfully sue you for libel with this type of attribution.

In a criminal matter when an arrest has just been made and you have photographs of the person being taken to the patrol car, always try to check the address immediately if you are going to call the number listed in the telephone book. It may be a half hour or longer before the family is notified of the arrest and stops talking to anyone. If you call right away, don't mention the arrest, but simply ask if this is the address of Gustaf Gambino, owner of the tavern. You will get cooperation. Calling later may not result in anyone being willing to talk.

Be certain you have an exact street address. Some cities have

identically named streets and avenues. It is conceivable that if you say Fordham and 6th or 1245 S. Sixth that you will be naming the wrong place, especially if both Sixth Street and Sixth Avenue cross Fordham.

How would a caption actually be written? Suppose you take photographs of a house fire, and one of the firemen is carrying a child from the burning building. A caption might read: "Fireman Bradley Hotfoot carried Johnny Lathem, Jr., from the flaming bedroom of the Lathem house at 3572 N. Winthrop. The 3-alarm fire destroyed the Lathem house at 3 A.M. today. The family, asleep when the blaze broke out, was alerted by Johnny's pet turtle, who nibbled at their feet to awaken them. Fire department spokesmen say the fire may have been started in the recreation room where the family's pet German shepherd was known to smoke cigarettes after the family retired for the night. However, the exact cause of the blaze has not yet been determined."

The caption is rather long, and not all the information would necessarily be used. However, it does tell who is in the picture, how the scene came about, what happened, when and where it occurred. Your notes on the back of the contact sheet should reflect the exact date, city, and state as well since the picture might be sold years later to a publication interested in illustrating an article on home fires. The inclusion of the state sounds silly, but you never know where your travels will take you. There is a Cleveland, Ohio, and a Cleveland, Tennessee, for example. You always run the risk of having someone attribute a city to the wrong state just because of the similarity of names.

Your captions can never be too long or contain too much information. A good editor can remove any caption material that is unnecessary, but how can an editor provide what you have not included?

When you have several photographs to offer, captioning them can be a hassle. You have to keep the caption and pictures separated; yet you want to make certain everything is readily identifiable.

There are several ways to link pictures and captions to-

gether. If a photograph is being sold for one-time use and will not be returned to you, you will not care what happens to it. In such a situation, many photographers like to type the caption on a sheet of paper, leaving several inches of white area at the top for attaching to the back of the photograph. The paper is attached to the back of the picture with a piece of cellophane tape or some rubber cement. This is a method for one-time use only, however, because the adhesive will eventually yellow the front of the picture. Rubber cement, for example, has been known to turn a black-and-white print slightly yellow after just a year. The chemical reaction is extremely swift.

My preference is to number each picture, making a small notation with a wax pencil, sharpened wax crayon or even a tiny notation with a pencil at the bottom of the reverse side of the print. The wax pencil mark is removable by using a tissue and gently rubbing the wax. The pencil mark should be placed in an area where it could be erased, but this is less advisable. Just be certain you place the picture face down on a hard surface before making the mark. Otherwise, you may print through to the front and effectively ruin the photograph's reproduction potential.

Next take a sheet of paper and title it CAPTIONS. Put your name directly below. Then double space, indent, put #1, and write the caption for the picture also marked #1. Double space between each line and quadruple space between each new caption. This makes your work clear and gives the editor plenty of space in which to make notes concerning your work. The editor may choose to send your typed caption material directly to the printer, in which case the space between the lines will be used to make notations concerning type size, typographical corrections, if any, and the removal of extraneous sentences that cannot fit into the hole available for the image.

With this procedure, you will have captions properly matched to the black-and-white prints and/or the color slides (the number is placed on the mount). There will be a dozen

separate, numbered photographs, if you have twelve different prints, a single paragraph with a single print, or whatever is appropriate.

I always use the numbering method when sending photographs to publishers other than my daily newspaper. Usually, daily newspaper sales involve spot news stories you chance upon. They are not carefully planned and are often written right at the newspaper office, due to time limitations. However, if I do have time, such as when I handle a story for a weekend magazine supplement, I treat the captioning exactly as I would for an out-of-town publication and do not attach anything to the print.

Model releases will be almost impossible to get when covering spot news stories and this is fine. They are not needed, and you should not waste your time trying to obtain them. You should also not waste time getting caption information during the heat of whatever excitement has caused you to stop and photograph. First you need the salable pictures. Then you need proper caption material. Far down the list of priorities, it is nice to obtain a model release.

The vast majority of model releases are used for advertising and public relations work. The subjects have been photographed in order to promote someone or something. There may even be a certain amount of distortion of reality for which the subject could otherwise sue. If model releases had to be obtained for editorial use, you would see far fewer photographs utilized by the news media. However, you still must be able to identify people and know exactly what happened at the accident, fire, or other event in order to sell your work.

When you actually must write an article to accompany your pictures, the same criteria of providing who, how, what, when, and where must be maintained, as must the accuracy of your reporting. You will also have the additional responsibility of explaining *why*. However, you have far more space in which to work.

Most magazines like to open an article with a certain amount of strong human interest appeal. Your first few

sentences must *grab* the reader's attention and keep him or her interested in reading further. If the reader is not interested in your first full paragraph, he or she will turn the page and go on to something else. Thus, that first paragraph, though providing some information, must also be as exciting and/or interesting as possible.

For example, when I wrote and photographed the story of Kathy Miller (a teenager recovered from brain damage) for *Family Circle,* the pictures were all current. They were visually appealing and caught the reader's interest. However, it was unclear just what might be happening. Thus, my opening paragraph was in sharp contrast to the pleasant photographs appearing over half the page. I wrote:

> Barbara and Larry Miller were breathless when they reached the small shopping area near their Scottsdale, Arizona, home. They pushed through the crowd of people gathered in the street, reaching the limp, bloody figure sprawled on the pavement moments before the ambulance arrived. Kathy Miller, their 14-year-old daughter, had been hit by a car with so much force it literally knocked her out of her shoes. Her face was battered, her leg was twisted grotesquely, and her breathing was shallow. Not knowing what else to do, the Millers knelt by her body and prayed.

If you remember, from an earlier mention of this story, the photograph that first strikes the reader's eye is of the entire family running down the street. Other images include Kathy working out in a gym and doing her homework. The photographs are in sharp contrast to the scene of tragedy I used to start the article. The purpose of that verbal/visual contrast was to arouse the reader's curiosity and to keep him reading. I also supplied a few answers by giving Kathy's name, the names of her parents, and the city where everything took place.

The second paragraph added some additional information. It stated:

The accident occurred in March of 1977. Kathy Miller was in a coma from which the hospital staff never thought she would emerge. Ten weeks later Kathy did awaken but nothing more. She didn't move, smile or give any indication that she recognized anyone. She had no control over her bodily functions and the doctors feared she might be a "vegetable" all her life. Less than one year later, Kathy Miller was named the Most Courageous Athlete by the 141 nations which form the Victoria Sporting Club. How she triumphed over her injuries is the story of the selfless courage of the entire Miller family.

The obvious differences between caption writing and the writing of an article are in their length and dramatic impact. The caption only has space for basic facts. The article has room for the facts presented in such a way that they are exciting to read. There is also plenty of room for elaborate details. A caption would just say that she had recovered from brain damage and won the award. It is only with an article that you must recreate the scene with words, not just pictures.

As I mentioned earlier, you do not have to write to sell your photographs. The caption material you must supply is simple. You give the basic *who, how, what, when,* and *where* of an incident, and a staff reporter or editor will work it into proper form if you failed to do so. The article is more elaborate, and you will not be expected to provide it yourself, though you may have to supply an article with outside assistance. The *Family Circle* material on Kathy would not have sold had I just had the photographs. However, I did not have to write the article myself. I could have collaborated with a writer such as a newspaper reporter in the city where the Millers live.

Talk with the publication for which you wish to do a story. Sometimes the magazine or other publication will have contact with a freelance writer in your area who will handle the writing. In fact, there are times when the writing is so easy to research that it does not require the writer to be present in your area. He or she can simply look at your photos, get some

general background, then call the people involved, and con-
duct the interview over the telephone.

More involved work, requiring the article interview to be
conducted on location, must be handled by your teaming up
with a staff writer from the publication, a freelance, or
someone who is a staff writer somewhere else and needs extra
money. The latter usually means your working with a reporter
for an area daily or weekly newspaper. Simply contact the
City Desk and ask if someone might be interested. If you have
been trying to freelance through the newspaper, the editor(s)
with whom you have talked might also be able to provide
some leads.

There are two ways to work with a separate writer for an
illustrated article. One is to have each of you get paid
separately, according to the rates normally paid for each
service. This has always seemed the best way to me even
though it is not the most equitable. *Family Circle* pays far
more for articles than for photographs although only the
photographer is likely to get expenses added under normal
circumstances. However, if the magazine has a low writing
rate but follows the rate for pictures set by the ASMP (Ameri-
can Society of Magazine Photographers, also known as the
Society of Photographers in Communication), you will proba-
bly come out ahead of the writer. In other cases, it can be a
toss-up. For example, an article for the trade journal *Nation's
Cities,* read by mayors, city council representatives, and city
managers, will receive a flat rate. The pay for photographs is
determined by the number used, each print receiving a set fee
no matter how many are used. An illustrated article I did for
the magazine resulted in enough picture sales to equal the
writing fee, and several articles by others had enough pictures
that the photographer did far better than the writer.

An alternative to such hassles is to split the money evenly,
regardless of how it is paid. If you do this, and it is probably
equitable, I would also split all expenses evenly. In addition,
some agreement should be made on the chance that one of the
photographs is selected for cover use and the publication pays

a high fee for that cover. This may not be a consideration. But it can happen, something you should keep in mind. Depending upon the magazine, a single color photograph used on the cover could earn more than the fee paid for the illustrations and article used inside.

The question of rights invariably arises each time you sell a photograph. When an article is sold, usually the purchaser buys all rights to it, and the same article cannot be used elsewhere. However, the writer can use the same original research material and write a second and third article, each of which is radically different in viewpoint and approach, for other magazines. For example, the article on Kathy Miller in *Family Circle* is unique. However, I did a story from her point of view for *Seventeen* magazine and a third story, again radically different from the other two, for *Success Unlimited.*

Photography is treated differently in the publishing world. Rights are sold for one time use as a matter of course even though some publications will try to lock up a picture forever. For many years, and occasionally even today, you will receive a check, the back of which is actually a contract. It will read something to the effect:

"Endorsement of this check constitutes the release of all rights to the photographs used in ＿＿＿＿＿＿ Magazine. The photographs become the exclusive property of ＿＿＿＿＿ Magazine, and this check represents payment in full."

The idea of the contractual check is to take advantage of the photographer. No matter what the written or implied agreement in the past, you seemingly cannot get your money unless you give up your pictures. However, such check endorsement stamps have been tested in court and, at this writing, have been found to be totally improper. They are worthless as contracts, and you are not held to them.

Knowing that, I say you are not legally bound to a contractual check clause and actually believing it are two different matters. There is a chance you will receive one and, if you are like I was at your stage in sales, will want to endorse it regardless just to get the money. After all, the idea that anyone

wants to publish your work is appealing, and to get paid is even more exciting. Fortunately, there is a way you can avoid hassles, get your money, and not have any chance of being obligated to what has been spelled out on the back of the check.

The simplest approach to avoiding the endorsement problem is to just not endorse it. Your name is on the front and the only time your name is needed on the back is to cash the check. You can *deposit* it in your account without adding the endorsement. Just write the words "For deposit only" underneath the contract stamp and put it in your checking or savings account. There are no hassles and no other endorsements needed. If the teller argues about it, and this is doubtful, see the bank manager. You are within your rights, and you will be allowed to make the deposit.

A second approach is to endorse the check after crossing out the stamped clause. This also invalidates the contract. In fact, whenever I sign an actual contract, there are occasions when there is a paragraph I will not tolerate. I cross it out and place my initials to the side of that paragraph. This invalidates it regardless of whether or not the publisher agrees. The rest of the contract is completely binding.

Remember that the bank doesn't care about the stamp on the back, only about the information on the front and whether or not the company issuing the check is solvent. You can give the bank a properly endorsed check with the contract stamp crossed out, and you will be able to cash it. Only the information on the front must not be obliterated.

Many photographers further protect themselves by having a stamp made up that specifies how each photograph is being sold. The rubber stamp, produced by almost any print shop, will read something to the effect:

"Photograph offered for one time use only. Payment must be made each time photograph is published." This is placed on the back of each print along with your name and address.

Slides present a problem because stamps are impractical.

The answer is to use an indelible marking pen with a narrow point and carefully print something such as "For One Time Use Only" on the mount.

There are some legitimate restrictions on the sale of photographs after they have been purchased by a publication. A morning newspaper does not want to buy your photographs of a spot news event and then see the identical prints in the afternoon paper. Nor does the paper want to see your pictures in an out-of-town paper that has identical circulation coverage within the city. For example, the morning newspapers in both Tucson and Phoenix, Arizona, are sold in quantity in the opposite cities, even though their news is primarily local. The afternoon papers, on the other hand, are limited to circulation to their cities of origin. Thus a picture series sold to the Tucson morning newspaper could be sold to the Phoenix afternoon paper without there being a conflict of interest. However, those prints could not appear in either the Phoenix morning paper or the Tucson afternoon paper without there being a conflict of interest on my part. Likewise, there would be no problem with the pictures being sold to both the Tucson and Phoenix afternoon newspapers since they do not compete.

Competition is usually the key to how you can sell photographs. A weekly and daily newspaper are not in competition except on the day they both appear. If your photographs appear in a daily newspaper on Sunday, the editor of the daily would probably have no qualms about your selling the identical images to the local weekly so long as they appear a few days later.

The same situation is true with magazines. A magazine expects to buy pictures which will not be seen in competitor magazines. My pictures of Kathy Miller were exclusively for *Family Circle*. This means they cannot appear in such rival magazines as *Woman's Day, Good Housekeeping,* and the like. However, no one would care if they were used in an article on photojournalism prepared for *Popular Photo-*

graphy, because that publication is not a competitor regardless of the fact that both magazines probably have readers in common.

Sometimes you run into a situation where a magazine wants an exclusive within a whole country. For example, *Stern* magazine, the German publication somewhat akin to the old *Life* magazine in the United States, has a policy of buying freelance photography with the understanding that the pictures will not be used in any other German publication until after they appear in *Stern.* The photographer would be free to sell the identical images to *Paris Match,* a French magazine similar to *Stern* that happens to circulate in Germany. The pictures could also be sold to British magazines, Italian publications, and others, all of which can be found on some German newsstands. The restriction is simply against sales to German magazines and this seems quite fair.

Another restriction can involve time. You might not be permitted to resell the pictures for six months or some other period after publication in whatever magazine has purchased them. However, if this is the agreement demanded, make certain that a specific publication date is stated. If no publication date is specified, allow a reasonable time for their use, such as one year from the date of purchase, and have the additional six months tacked on to that. Thus, the agreement might state that the pictures cannot be sold to anyone else until a period "six months after publication, assuming publication occurs within 12 months from (date). If publication does not occur within 12 months from (date), the photographer shall have the right to resell them 18 months from (date)." Naturally, any similar wording is fine. All that matters is that everyone's rights are protected by having all contingencies covered.

Never feel that you cannot understand a contract offered when you go to sell your photographs. Most publications don't bother with contracts. Verbal agreements are made, such as with newspapers, or a written agreement is made through a letter accepting the work. However, some publications do

insist upon contracts, and these prove intimidating for many photographers.

When you get a contract, read it over and think about what is being said. Never mind what the editor promised would be in there. All that is legally binding are the exact words of the agreement you have been sent. Whatever is included is the total obligation. Promises are meaningless.

Once you have read the agreement, think about whether or not you fully understand everything stated. Some editors dismiss your confusion by saying "It's lawyer talk. Everything's all right." However, this is nonsense. A contract should make sense even if the lawyer uses a lot of fancy phrases to try to justify the high bill being sent to the publisher for that contract's preparation. If you don't understand something, chances are that it is going to be unclear even to another lawyer. Some attorneys get so carried away with their language that they leave loopholes in the contracts. When this occurs, you may find that everyone, including the publisher, assumed your rights were protected only to discover, after signing, that you have been shafted. The editor or publisher may state that the problem will be corrected and you shouldn't worry, but such a person may retire or take a job elsewhere. The new person will read the contract and follow it to the letter.

Be certain you can understand the contract without consulting an attorney to clarify something. If there is confusion, ask for a written clarification, which will be initialed by all parties and will be attached to the copies of the contract.

The vast majority of contracts present no problems for anyone. However, I once had to work with a publisher of photographic books, now out of business, whose staff used a lawyer who was trying to impress the world with his knowledge of Latin and obscure legal phrases, which I doubt even he understood. I kept seeking written clarification of the contract and he kept avoiding the issue. Finally, I called the publisher and asked exactly what benefits I would get, what was expected from me, when everything was due, and the

other terms of the agreement. She told me everything I needed
to know, and I then wrote this in plain English, made several
copies, and had places for everything to be signed, witnessed,
and dated. I sent them to the publisher, with my witnessed
signature, and suggested we use them instead of the legal
contract.

The publisher was shocked by what I had done, even
though she also couldn't understand the contract the attorney
had made. She turned what I had written over to the attorney
who became angry, blustered around a bit, and then said,
"Well, that's certainly not the way I would write a contract."

"But does the statement say what should be in the contract,
and is it legally binding?"

"Well, I suppose it says what I said but not in any way a
lawyer would have done it. And it is just as legally binding as
mine. But . . ."

"That's all I needed to know," said the publisher, taking
the agreement I had written and signing it. She also never
used that lawyer again.

The situation was unusual I will admit. However, it reflects
what can happen in this business, and you should not feel
intimidated just because you are a creative photographer and
not legally trained. A contract is nothing more than an
agreement between two or more people. It should be under-
standable to everyone and state exactly what is involved for
everyone. If it fails to do this or you even think it might fail
to do this because you cannot understand the wording of the
agreement, then you need to have some changes made *before*
you sign.

Some photographers feel they have photographs that have
great potential for sale but only within a limited time period.
It can take an editor as long as eight weeks to make a decision
concerning your work under the best of circumstances, and
this may be too long to wait if you have to offer it elsewhere
in a short period of time. For example, suppose you have
some pictures that, for one reason or another, are perfect for
the Christmas holiday season. Again, for some reason, they
will not be usable after this year, and you are starting to offer

them in June. Most publications will have prepared their December issues by August or September at the latest, so it seems as though you have a one-shot chance at selling them. If the magazine to which you send the images has an editor who takes a while responding and if the publication rejects them, then you have lost your chance for a sale.

The answer seems to be to make several copies of the photographs and offer them to each magazine that might be interested, including competing ones. All your mailings are done in June, an appropriate time for the use they must have. Then you either go with the first publication to respond or with the highest bidder if you feel you have a few days to wait and see what offers come in.

The problem with simultaneous submission is that editors have frequently resented such actions. They feel that they will see the work, become wildly excited about it, want to buy it, and then be told you have sold it elsewhere. Some editors have been known to automatically reject future photographic submissions by the same photographer under such circumstances, especially when the photographer did not admit that the images were simultaneously submitted until after the acceptance had been sent. This can be especially embarrassing if the publication is laid out for them and a check is sent at the same time the photographer is notified of the acceptance.

Fortunately, editors are becoming more realistic about freelance photographers and their problems. They realize the cost of taking pictures, having prints made, and mailing them to the magazines. They also realize that there are circumstances where time is of the essence and a reply may not go out quickly enough to allow the photographer to sell the work elsewhere. Thus, they have become more sympathetic to the whole concept of simultaneous submissions.

If you must make simultaneous submissions to magazines, be certain you tell the editors right at the start. This information should be in the cover letter, and you should include a telephone number the editor can call *collect* to see if the work is available. Unfortunately, you will still be penalized slightly because, if the editor calls with an offer, you will be expected

to take or reject it immediately. This is only fair because the publication has to assume you have made simultaneous submissions due to the timeliness of the work, not because you want to play games with money.

The answer to this situation is to choose magazines of comparable size that pay comparable rates. The information is in market guides such as *Photographer's Market* and *Writer's Market*. (See the section with lists of where to send your work.) Unless the photographs are of startling importance, comparably sized magazines pay similarly, and you should go with the first offer.

Assuming you talk with any editor directly rather than through the mail, you might want to try something I occasionally do. The editor will make an offer and say, "Is that all right with you?" I then laugh and say, "What will happen if I say no."

Usually the editor replies, "Then I'll say goodbye." At such a moment I laugh and say, "Then I accept your offer." However, upon occasion, I have had the response, "We can go an extra $50, but that would be our top bid." Naturally, I accept the extra money.

The majority of publications are fully legitimate, and you will not have problems with them. They are also not used to arguing over money in most cases. There is a set budget, and the amount of money to be spent on each type of article is known. The rate for photographs will seldom vary.

In general, freelancing involves common sense. There is competition in this business and there are editors who may try to take advantage of you. But the majority of people are completely honest. By dealing with established publications and making certain all promises are in writing, you will have a successful time handling all aspects of the legal end of the field.

Caption writing for proper attribution is much the same. When you make certain you have answered the five questions of *who, how, what, when,* and *where* accurately and completely, you will satisfy both the editorial and legal needs.

6

The Book Market

The ultimate fantasy of just about every freelance photographer is to one day have his or her photographs included in a book. This might be a book in which just one or two photographs appear or one that reflects the exclusive work of the photographer.

As you have seen in previous chapters, being included in a book is not that different. After researching publishers to learn who is putting out books using illustrations, sending a query letter to the editor, publisher, and/or art director will gain results.

For example, suppose you decide to contact the publisher of reference books that use photographs, such as encyclopedias. A typical letter might read,

Dear Editor:
I am a professional photographer interested in selling you one or more photographs for use as illustrations in the books you

publish. I have both black-and-white and color photographs covering a variety of subjects including scenics taken in Pennsylvania, California, Utah, and other states, general scenes of both urban and rural life in the midwest, close-up photographs of insects, pictures of industrial plants in Pittsburgh, and general photos of people in parks, on streets, and otherwise interacting, as well as other categories. I am interested in supplying photographs to you for use as illustrations in the books you publish. All material will be sent on speculation, and I will provide a complete list of my file work if desired.

The next paragraph would give my background. However, if you have no credentials that are meaningful, I would simply say something to the effect of:

Thank you for your consideration. I hope to hear from you at your earliest convenience. If you are not the person who reviews freelance submissions of photos, I would appreciate your forwarding my letter to the person who is responsible.

Then I would close, signing my name, address, and telephone number(s). This is all that needs to be sent, though the self-addressed, stamped envelope is, of course, essential.

Basically, the photographs will be requested according to topic and need. Sometimes the type of equipment is a factor. One of my photographs is in the *Nikon Handbook,* and one of the criteria for acceptance was that it be taken with a Nikon. The fact that I no longer use Nikon equipment prevents me from sending current work to future volumes.

Usually, equipment is of no consideration. A book on sailing needs photographs of people using sail boats. Occasionally a particular model must be shown or the photograph must emphasize a safety technique. All this will be explained when the pictures are requested. It is best if you know the type of work you have on hand in advance.

Other times the pictures will be selected because of the general theme. The publisher will want street scenes, night city scenes, bus stations, cars from 1957, or some other general topic. You send what you have that both relates and is of

professional quality. Then the selection is made, and one or more photographs will be purchased from you if that is appropriate.

All this is very similar to what happens with magazines. It is only when you get into the field of books containing your own work entirely that questions arise.

After many years as a freelancer with numerous books to my credit, I am convinced that if there is a market for a book you want to produce, there will be a publisher interested in handling it. This notion is in direct opposition to the people who insist that the only way a beginner can get a book published is through self-publishing. Such notions are encouraged by companies that publish only books paid for by the photographer and/or author. The notion is also encouraged by many would-be authors and college teachers I have met. Fortunately, they are all wrong.

The idea that self-publishing can be of value seems, on the surface, a good one. You exercise total editorial control. You select the images, plan how they will be laid out, add whatever captions you feel belong, and dominate the project from start to finish. The book is produced exactly as you want it and distributed according to plans you approve. Besides, you get 100% of the profits after costs are met.

The theory is terrific. The reality is terrible. You are a photographer. What do you know about reproduction in book form? What do you know about printing paper for books? What about type faces? Marketing? Advertising? How much time can you spend trying to get the book into book stores? Who will review it?

Publishers who produce books for which you pay the costs are known collectively as the vanity press. Unfortunately, their advertising sounds impressive. They show the eight or ten books that have truly sold well over the years, including the one written by a particular vanity publisher sent to just about everyone in the world when they ask about his company, thus building impressive printing figures. They don't say that the majority of books they handle do terribly.

Advertisements for vanity publishers are marvelous. They

list a half dozen famous names and ask what the people had in common. The answer is always that the people paid to have their first books published, a fact that is meant to convince you that *everyone* pays to have a first book published. What they don't say is that in most cases, the famous names who paid the first time also had first books which were terrible. They showed none of the genius that eventually resulted in their becoming *names*.

A minority of the cases mentioned in ads reveal that the books were competent and, occasionally, quite good. However, the authors had no marketing sense nor any idea of who might be interested, and they became discouraged when a half dozen or more markets (inappropriate ones) turned down their books. Had they known what to do by reading a book such as this one, they never would have had the problem.

If name authors really believed that the vanity press was of value, why would they use such publishers only once? Why would they go through normal publishers who pay them a percentage of the gross rather than getting the high profit of 100% after costs are met?

Fact: The vanity press publishers almost always advertise your books in media where they know you will see it. When the newspaper *National Observer* (Dow Jones Publishing) was a news weekly of great stature, read by many people who had the money to publish their own books, the vanity press often advertised there. Now that the *National Observer* no longer is in business, many of the vanity press publishers use *Time* and *Newsweek*. These are magazines you are likely to read, but when was the last time you bought a book in the bookstore based on an advertisement, small at that, placed in such a magazine? If a book is not in the bookstores or offered by a major book club, chances are you will never buy it.

Fact: Legitimate publishers often advertise in magazines you might not know exist. These include the book publishing trade journal *Publishers Weekly* and the *Library Journal*, both magazines read by the book buyers of bookstores and libraries. Such people first become aware of books this way, and many books for resale in their stores are ordered based on the

advertisements in such volumes. However, because the people who pay to publish their books are unlikely to read these magazines, no ads are placed there by the vanity press. If advertisements were placed in the trade journals, more books might be sold, but the writer and/or photographer would not be happy because he or she would not know about it. Worse, the family and friends of the author would not know about it, so there would be no ego boost from people calling to say they saw the book being advertised.

Fact: The majority of bookstores will not accept books published by the author. Vanity press books are seldom reviewed or seldom promoted in a way that results in orders from the stores because they would end up taking space needed for profitable books. Occasionally a bookstore will take a local author's book as a favor, and some stores, especially in university areas where self-publishing is more prevalent, give a small section to "local authors" and will stock three or four volumes of a self-published author. However, almost none of these sell, and it is a community relations gimmick for the store owner. It is next to impossible for a self-published author in Maine to get his or her photo book in a California bookstore.

Many people will counter my argument by stating that they know about a self-published photographer whose book has sold thousands of copies. They read about this person in the newspaper or magazine. What they fail to realize is that they read about the self-published photographer because the feat was newsworthy. The commonplace is not *news*. Over 35,000 different books are published a year, but you never hear about the majority of the authors when they are published by normal means because they are not newsworthy. Their books sell to varying degrees. Vanity press books are among those that will almost never sell, and so a successful self-published individual is a true rarity.

Self-publishing is obviously not the way to go in the photo book business. So how do you break into it? How do you plan a book and go about finding a publisher?

The first step toward getting a book published is to develop

a sense of direction. What type of book would you like to do? Usually there will be three major categories, any one of which may be perfect for you. The first is the how-to book. The second is a collection of photographs with a common theme, and the third is a book of art photos that might involve darkroom manipulation, montages, multiple exposures, and almost any other technique. The images are not straight photographs but rather works of impressionist art that usually stand alone.

The how-to book is probably the easiest to get published because there is a tremendous demand for such work. Never mind that you are not the greatest photographer in a particular area. If you have salable photographs in a field such as architecture, theater work, available light, weddings, portraiture, travel, or food, chances are that you can put together a salable volume telling others how to take the same work.

There are very few how-to books written by the finest people in their fields. The majority are written by extremely competent, knowledgeable individuals who work in the areas regularly but who are not at the top. For example, if you are currently working as a portrait photographer or doing weddings several times a month, and if you have been doing this for more than a couple of years, then you probably have been satisfying your customers. You know how to handle lighting, the camera, and even the psychology of getting someone to relax. You are doing precisely what thousands of camera owners around the country would like to do but don't know how. You may not be the equivalent of someone who charges $500 or more per sitting, but you do have knowledge others will pay money to learn. If you produce a book telling what you know and extensively illustrate it with your photographs, you will have a highly salable property.

One of the nicest aspects about the photograph book field is that few books stay in print more than three years. Every time a rash of books on a particular subject appears, such as portrait work, the market for new works is eliminated. However, wait a few months, and suddenly the editors of book publishing companies handling photography volumes are

delighted to hear about new titles relating to the same subject. Thus, if there is too much competition at the moment, it does not mean that there will never be a market for your book. It simply means a delay.

In order to produce the how-to book, you must first decide the area in which you want to write. This will probably be a field you're well experienced in or at least one in which you have taken extensive photographs. You have a backlog of pictures on file so your only problem will be organization.

You are not limited to pictures on file, of course. I regularly produce books on model photography, but model photos do not comprise very much of my week-to-week work. The model photos I normally take are used extensively in books and magazines around the world, and I am quite experienced in the field. However, each time I sell a new book, I hire new models, find different locations than I have used before, and take at least 1,000 photographs just for illustration. I may only use a fraction of these images, and I may rely heavily on what is on file already. But I like the challenge of taking new photographs, and I like being able to show illustrations involving faces the readers of my past works have not seen. This is my choice, though, and I could also work from file, as you can.

A how-to book must be carefully planned. The first consideration is your audience. Whom do you want to read this? You can assume that the top professionals in the field will not be interested because they are working every day. Thus, this is not a predictable market even though a truly good professional probably buys every new book related to his or her field to be constantly stimulated by the way others see the same subject matter and by new information. Learning in photography is a continuous experience. The only way the best people stay that way is through constant growth.

Next, what will you cover in the chapters? Among the topics that are of consistent interest, regardless of the subject of the how-to, are equipment, technique (actually taking the pictures), lighting, posing (when applicable), overcoming

special problems (using regular lenses for architecture photos, handling color film when faced with fluorescent illumination, etc.), selling the pictures, legal aspects (use of a model release when applicable), and similar areas.

Being more specific, I will show my thinking when planning an architecture photography book. This would be a how-to volume of the type you might be interested in.

First, there is the market to define. The majority of the people interested in getting into this type of field will not be the professionals owning view cameras that offer swings and tilts. They will own 35mm and, perhaps, roll film cameras. They want to work with architecture right now and wonder if that is possible. It is, of course, but they will not be certain about how to handle their cameras effectively.

My first chapter would probably detail equipment. I would discuss such areas as the use of small cameras (35mm and roll film SLRs) for architecture, perspective control lenses, and the times when the full swings and tilts of view cameras might be needed. I would detail how the film plane must always be parallel to the perpendicular lines of a building in order to avoid distortion, a fact that allows the use of normal camera lenses. I would also show how several images of a building can give the same information as one image taken of the entire structure, a picture maybe possible only with perspective control equipment.

The second chapter would detail technique. I would discuss the photography of both interiors and exteriors. I would tell how to record both high and low buildings. Everything would relate to using normal and wide angle lenses available for every type of camera. It would only be in the third chapter where I might relate the special information concerning perspective control lenses and view camera equipment. This chapter would be brief and provide general information only. I am assuming that a book of this type would be bought by someone who wants to use his or her equipment in ways that are more involved than in the past. The person does not want to have to buy anything more than he or she owns in order to

enjoy the field. However, the person might wish to eventually buy such equipment, and I want the book to give him or her an understanding of what such items do.

The fourth chapter would discuss lighting. I would cover available light techniques both inside and out, taking pictures at night, fill light, painting with light (a variation of fill light in which heavily shadowed areas receive repeated flashes of light during a long time exposure), problem lighting conditions (tungsten/daylight mix or fluorescent lighting), and other similar situations. I would mention types of inexpensive lights as well as the sophisticated quartz and high powered electronic flash lighting. Types of film would be explained, including how the different types of lights affect both color and black-and-white.

The first five chapters actually cover all the areas of great importance to the reader. Additional material would be optional. For example, I would consider having information on the storage of prints and slides, including a card file system, so you can retrieve specific images of specific buildings without having to study every contact sheet. I might also have chapters on business related subjects such as how to figure the cost for taking an architecture assignment, desired profit, billing, and the like. There could be information on how to sell photos to architects, building and home owners, and magazines related to the field of architecture and interior design. All of these areas would either come from my knowledge and experience or through interviews with experts in the field.

The book itself would not have to be prepared in its entirety in order to interest a publisher, though some photographers find this the easiest way to handle the production. The minimum you will need will be a chapter-by-chapter breakdown with full information about what will be covered, a sample chapter fully written and a set of black-and-white and color photographs to show your versatility. I seldom send less than fifty photos total with two thirds of the work being black-and-white, but this number is arbitrary. You could also send all color slides, which is far cheaper to do, because most

editors assume that if you can handle color, you can easily take photographs in black-and-white. They do not assume the reverse to be true, though such thinking is not unwarranted.

Finally, your cover letter should explain that you are a professional architecture (or model, available light, theater, or whatever) photographer interested in doing a book on the subject. Try to give a breakdown of the potential buyers as thoroughly as possible. For example, an architecture book will be bought by advanced amateurs, professionals currently working in other fields, and people just interested in looking at photographs of architecture. There will also be a large market in realtors who are not photographers at all but who are given Polaroid and 35mm cameras, then told to photograph new listings. Such people need basic information on taking decent looking pictures with simple equipment.

The combination of the cover letter, justifying the reasons for publishing your book, the sample chapter, breakdown of chapters, and sample photographs will be all you need to get a contract. However, offer to send additional chapters and photographs on speculation. The term *on speculation* is as important here as it was when submitting to magazines, and for the same reason.

A second type of book is the book of photographs based around a central theme. This might be a photo story of a young ballerina, an extremely successful concept for photographer Jill Krementz, pictures of the changing face of your community, an in-depth study of a ghetto area, or just about anything else. The important point is that the pictures are based around one concept and, for the most part, the total book tells a story.

The book of photographs based around a central theme is one of the more difficult books to sell because it is so easy to go to the wrong publisher. However, with a little thought concerning the potential market, it can sell far better than the how-to books.

For example, suppose you want to photograph the changing face of your city. In order to do this, you have shown

older buildings, buildings being torn down, new construction projects, the old, the young, winos, people inside cafes, and all manner of relevant material. There may be pictures with great emotional impact, brilliant technical execution, and the revelation of an insightful vision in the work. Unfortunately, if your city is Dayton, Ohio, and not New York, there is a chance that a major publisher will not be interested.

Does this mean you can't publish your project unless you do it yourself? Of course not. You just have to change your thinking.

Who might be interested in the book on your city? The people within your community are a major target for sales, and the people in your state form a secondary sales market. This is too small a market for a publisher relying on national sales with a multi-million population base. However, this is not too small an area for a regional publisher.

Regional publishers are not just those publishers located outside of New York. Rather, a regional publisher is someone who specializes in producing books for sale in a limited area. For example, a major publisher might need to sell a minimum of 5,000 copies to begin making money. A regional publisher might think in terms of a first printing that is one-fifth this size. The books will be sold within one community that has the most interest.

Regional publishers include both publishing companies specializing in a specific area, such as the state of Arizona, and university presses which also limit their markets. The university press will publish books relating to the staff work, specialty areas such as anthropology and local history in the areas surrounding the university. There are also one-shot publishers such as chambers of commerce and historical societies that become interested in a book project, produce and sell it, then go months or years without doing another book.

The book on Dayton, Ohio, would interest a publisher specializing in Ohio history (see list of market guides), a historical society, perhaps a university, and/or the chamber of commerce. There might even be a civic group interested in the

preservation of the city that would want to underwrite the cost of publishing to make the book available to the public. The total number of books printed in this way would be relatively small, of course, but they would not be done at your expense. Marketing would be simple because the books would only be sold locally, and local outlets would be delighted to take them for the civic good. Often major businesses such as banks buy a quantity of such books and give them away or sell them at cost as an advertising gimmick.

How do you go about selling such a specialized book? Usually you have to have a series of photographs to show, and this means at least the fifty mentioned earlier. Include both color and black-and-white, though remember that printing costs are such that a regional publisher may seek all of one type picture or another. Usually this means the sale of black-and-white but not necessarily. States known for their scenic splendor, especially in the West, often have books printed in full color, at a cost of about twenty to thirty dollars each, and they still sell well enough to make everyone a profit.

A regional book is expensive for everyone. You have to work without an advance in most cases or put in for reimbursement each time you have to spend money on film and processing. Often there is no guarantee of payment until costs have been met, and costs might never be met. However, having your work bound in book form is more than just an ego boost. It helps establish your professionalism, and you are not considered foolishly naive the way you are likely to be if you try to pay to have your work published.

The third type of book, rather surrealistic in nature, is the least often tried and of interest to only a small number of buyers and photographers. Usually a major publisher will be needed, and to broaden the appeal you might have to team with a writer whose poetry and/or prose you would illustrate. Because the work cannot be described, it will have to be sent before you know if there is an interest. Publishers of poetry and art books are your best markets for this sort of thing.

The contract you get for a book will vary with the type of book, your reputation, the publisher, and a number of other factors unique to each individual situation. Basically, you will be working with an advance and a royalty scale. These are the key factors in the contract for the producer of a photography book or a heavily illustrated book (the how-to variety).

There have been many news stories about authors making fabulous sums of money for the advance on their books. However, these are always big names with either an established audience for the volume or a subject that is extremely popular at the moment. They make news because the majority of authors receive little or nothing for the advance. A fee range of from nothing to perhaps $1,500 is normal, with some photography book publishers going a thousand dollars higher. There are far higher fees paid, of course, but you are not likely to get one with a first photography book. There is too great a chance that the book will fail.

The money is paid according to your reputation. A beginning photographer/author may receive nothing upon signing the contract and either everything on acceptance of the material or a portion of the money when you have satisfactorily supplied half the work. A person who is trusted more will receive a portion of the advance on signing—usually one third of the money—a second sum halfway through the book, and the remainder upon satisfactory completion. Eventually, you will receive half the advance on signing and half on final acceptance, but this may not be the case at first. The publisher must feel comfortable that you will do the project as planned, and this usually requires a proven record.

Most photographers picture themselves as artists, a situation to which I also must plead guilty. We have a certain style of taking images, we know the project we have in mind rather intimately, and we are concerned with the final appearance of the book. We also lack any sense of objectivity and are not the best judges of what we do. Because of this, you must face the reality that when the book is completed and the editor looks

at the photographs, he or she may decide that massive revision is needed. New pictures might have to be added or our favorites removed because they don't meet the publisher's needs. You are given the choice of making the changes or abandoning the book, and surprisingly, some people become temperamental, refusing to do anything further. They lose the opportunity to be published in this way for reasons that might not even be valid. I always feel that no one is the best judge of his or her own work, and that the editor has ideas at least as valid as our own. In some cases, we are so close to our own work that the editor is actually a better judge of what has been done and what is yet to do. However, if we don't respect this fact, there can be serious problems.

I have found that few editors know the number of photographs they will need for a book. Usually they underestimate, and I like to have at least 50% more prints in reserve than I send. Often I have as many as double the number of black-and-white and/or color images necessary, though retained in file. These are all of a caliber that will allow me to use them for the book but are occasionally not quite so good as the ones sent under contract.

The book you produce may involve illustrating something in a totally controlled manner. For example, suppose you work with the writer of a book of poetry. You are to supply one photograph per poem, and that is what you send. What you fail to realize is that the editor may see a poem somewhat differently than you do. You may be asked to send another two or three images from which a final selection can be made. If you are not ready to do so, this can be a problem.

The deadlines you receive should be considered sacred and inviolate. Most photographer/authors are late with their work, and I know one publisher of such books who frequently assigns a deadline that is six weeks earlier than the work is needed. However, being lax like this and missing a deadline make you look bad. It must not happen with newspaper and magazine work if you are to keep the respect of the editor. It should not happen with books. When it does, the publisher

may not use you again or may buy your work less frequently than would otherwise be the case. Thus, you should always start a book as soon as you get the contract and do everything possible to get the images in his or her hands well in advance of the time they are due.

Try to get as much mileage from the photographs in your book as you can. If the publisher has no objections, see if you can sell occasional prints from the various chapters as you are completing the book. A how-to book might even result in your being able to sell whole chapters as articles. Naturally, you do not sell the chapter as written. What you do is take the research knowledge gained from doing the chapter and find a way to sell it as a unique article. The architecture book, for example, is an obvious one. However, if you are doing a photo story on your city, why not sell parts of it to your newspaper's Sunday magazine supplement or some other special section? Some of your images might fit trade journals or other publications. It all depends upon what you have been photographing.

The fact that your publisher may object to your selling photos taken for the book need not stop you. Theoretically, you are taking far more photos than will be used in the book. Select images you know will be extra, even though the original intent was for the publication. In that way you are gaining extra income and exposure while not violating the publisher's wishes.

If you are not certain about the degree of interest one of your book project ideas might have and want to find a regional publisher, check with area bookstores. The owners can usually steer you to regional publishers from whom they buy books for resale. These will be publishers who are both legitimate and treat the stores fairly. They can be a good source of basic information of this type. Just be certain you do not try to use them to find national publishers. The majority of such owners are dealers in a product, not photographers. They can tell you their likes and dislikes. They can tell you about current book lines. But they don't know the future

needs as well as you will know them when you study the markets listed at the end of this book.

The book market is an excellent one for the freelance photographer if you do a little planning. By analyzing what you want to do, determining where there is an interest (local, regional, or national), and going after people who will pay to publish accordingly, you can have tremendous success in this field.

7

The Overseas Market

The needs of foreign publishers are as great as those of publishers in the United States. What makes them special from a photographer's viewpoint is the fact that to an editor thousands of miles from America, you are exotic. If two photographs of equal quality arrive at the office of a British, French, Italian, or other overseas publisher, one of which is from within that country and the other from you, yours will be selected for use. Admittedly, the editor may not say this and may not consciously admit to it. However, it is a fact which has resulted in my placing numerous photographs overseas that might never have been used within the United States.

There are several valid reasons for an overseas editor taking your quality work over that of an equal photographer at home. One of the most important is the fact that your images will be showing a culture unfamiliar to the readers. Haven't you ever marveled at images of the highland games in Scotland, folk dancing in Hungary, villages in Africa, and the

marketplace in Middle Eastern nations? Of course you have, because the images were exotic, different, foreign to your daily activities. However, did you ever stop to think that the people who live in those countries think nothing of what they are seeing. This is normal to them. Those pictures might be exciting and interesting, but they are also commonplace. When the images appear in the magazines published within their countries, they think nothing of them.

Now think about the rituals here at home in the United States. What about our modern marketplace—the massive shopping malls? Think of their designs, the way some people live there, such as the elderly with nothing to do all day and the teenagers without money who live there on weekends. Think about the products, the promotions, the musical groups who entertain during the week within the malls. How fascinating these must be for someone who has never experienced them!

The same situation is true for other experiences. What is a real American ranch like? How does a cowboy live? What are America's scenic wonders like? How does an American city police officer spend the day? How does an American family live in a suburb, city apartment, or rural home? What are supermarkets like? Department stores? Steel mills and manufacturing plants? No matter where you live, you are surrounded by subjects as fascinating to the French, Irish, Indian, Japanese, and others as their cultures are to you. And the magazines in those countries are aware of this fact.

Where do you find overseas publications? There are a number of resources listed in the appendix. Most of them will require you to obtain a sample copy of the publication, but this you should do anyway. There will be a charge, though you can often have that waived by saying something to the effect of:

Dear Editor:
 I am a professional photographer who has both photographs and ideas for illustrated articles I feel would be of interest to

your readers. However, before submitting anything, I would like to purchase some recent back issues for study. Would you please advise the cost, so I can get them as soon as possible?

The difference between overseas and American mailing is that though you will still supply the self-addressed envelope, you will not place a stamp on it. Instead, you will include what is known as an International Reply Coupon. This is available from the Post Office and allows the recipient in a foreign country to purchase appropriate postage in exchange for the coupon. It is the same as applying a stamp except that the coupon is sent loose. One coupon is all that is needed for a letter.

Notice that my sample letter stresses the intent to *buy* a sample copy. The reason for this is that the cost of magazines and postage has gotten so high that magazines that once could afford to mail samples for free no longer can. However, when you stress that you are a professional photographer and that you want to buy a sample, that combined bit of information will often cause the editor to bend the rules, because you will appear to be someone who might be able to provide material the magazine can use. In fact, only once have I been asked to pay for sample copies when approaching a publication in this manner. Of course, if you are asked to pay, the money is well spent.

Most of the magazines you may try to sell will not be in English. At first glance this will seem to be a problem for you, but it is only a problem for someone who is a writer, not a photographer. A writer needs to read the article and stories in order to understand the publication's style. This is impossible if the writer doesn't read the language in which the magazine is printed. However, you will not have this problem because you photographers know no language barrier. You will be able to see the type of images used and whether or not you can supply appropriate work.

You can even check the degree of freelance work a publication uses. Foreign publications, like those in the United

States, have a section in which the staff is listed. This might be on the table of contents page or somewhere else early in the magazine. It will list staff photographers just as is done with American magazines.

Take a look at the credit lines under the photographs. Then compare the credit name with the names on the list of staff members. If these are the same, then you will know the publication will probably not accept freelance material. If the names are different, you have a good chance of selling to the publication.

Many of the most commonly available publications from France and Italy are fashion magazines. Normally these would not be considered a market for a freelancer working in the United States. The magazines only want pictures originating from the fashion centers and often only from the fashion centers of their countries (Rome, Paris, etc.). However, glance through the pages of each such magazine to see if they have regular features you could handle. A number of such publications have picture stories relating to health, beauty, finance, and so forth. Features on Americans involved with unusual stories relating to these specialized areas are always in demand, regardless of the city from which they originate.

The easiest country in which to begin selling is England. It is far enough away for your pictures to be in demand; the language of the publications is the same as our own; and there is an excellent source for information on the needs, payments, and other details concerning British magazines. That source is the Bureau of Freelance Photographers, whose address is listed in the appendix with other market sources.

The Bureau of Freelance Photographers is not a formal organization in the sense of Professional Photographers of America, the prestigious group of American studio photographers and other professionals. Nor is the BFP along the lines of the American Society of Magazine Photographers, the organization whose members are involved with the magazine business and other media outside newspapers. Many BFP

members are professionals, though the majority are probably advanced amateurs just beginning to sell pictures for publications.

The cost of BFP membership for Americans is quite high. The price has been raised at least twice in the last couple of years and is not listed here because it may go up before you read this. However, if you are serious about submitting material outside the United States, the BFP is well worth the money.

The main benefit of the BFP is the Confidential Market Letter, issued monthly. It is a little like receiving a copy of *Photographer's Market* on the installment plan. More important, every second or third issue comes with an in-depth Market Survey Special, which details one field—its pitfalls and value.

The Market Newsletter lists new publications, the needs of well established publications, problems that have arisen, and so forth. For example, in the May, 1979, issue, the Market Newsletter had a warning which read:

> Some members have run into difficulties with SAILING magazine, which was published from 55, Shelton Street, London. We have been trying to contact publisher Brian Healey, but so far, without success. It does, however, appear that the magazine is no longer published. If any members have any information about the whereabouts of Mr. Healey, we would appreciate it if they would contact us.

Typical of the positive reports from BFP Confidential Market Newsletter are such entries as:

> BUILDING DESIGN is a weekly tabloid for architects, quantity surveyors, engineers, and building contractors. The editor, Peter Murray, will consider captioned black-and-white pictures of interesting new buildings. Also, illustrated articles on new buildings, historic and rehabilitated buildings, and modern architecture. Also, interviews with architects.

BUILDING DESIGN is published by Morgan Grampian Ltd., from 30 Calderwood Street, London SE18 6QH.

Another entry from an earlier newsletter states:

> NURSING MIRROR which—as reported in the December Newsletter—was recently relaunched with a new-style front cover and improved layout, does offer a market for freelance pictures, confirms Mark Allen, the newly appointed editor. "While most of our articles are written by doctors and nurses, we are interested in seeing freelance pictures," writes Mr. Allen. "Required are news pictures about hospitals or nurses, e.g. new hospitals opened, events taking place at hospitals or health centres, etc."
>
> Only black-and-white pictures are required, and payment is at the rate of 7.50 pounds per photo published. Submissions should, of course, be fully captioned.
>
> NURSING MIRROR is published from Surrey House, 1 Throwley Way, Sutton, Surrey, SM1 4QQ.

The Market Survey Special issues provide everything you could hope to learn concerning a specific market area in England. For example, a Glamour Market survey revealed the magazines that are the most legitimate in terms of what they expect from the photographer, the sums they pay, years in business, and integrity of the company. All possible markets are listed except those which pay so little that it is a waste of time to try them.

The information about the market starts with an evaluation of sales, as valid for Americans as British. One section states:

> Glamour magazines tend to be bombarded with material from hopeful freelancers—but probably as much as 80 percent of it is totally unsuitable. In fact, most of the editors we spoke to reiterated the complaints which they made when we last reviewed this market: "Photographers don't seem to understand our requirements . . . they think all they have to do is get a girl to take her clothes off, shoot a few pictures and sit back and

wait for the cheque! They haven't studied the market . . . they don't put enough thought into their pictures. . . . We get a lot of pictures that aren't even sharp."

Of course, even a technically and photographically perfect set of pictures won't sell if the model is unsuitable. Editors are constantly looking for attractive new faces. Remember that it is often impossible to sell pictures of very well-known professional models—simply because their faces have already appeared many times in one or more of the glamour magazines. However, so long as the girl is attractive, can pose naturally, and feels at ease without her clothes, she could make a successful glamour feature.

There was extensive information in this glamour section, including details about frauds. Then there were extensive market listings covering everything an American or British photographer needs to know about literally every magazine originating in England, which is a legitimate market. For example, one description read:

> CLUB INTERNATIONAL is a sophisticated "quality" men's magazine, in the PLAYBOY tradition, and similar to Paul Raymond's other glamour magazine, MEN ONLY. Only top quality colour material is required, and 35mm Kodachrome is the perfect format. CLUB INTERNATIONAL follows the usual quality men's magazine format, publishing a series of pictures of each girl, together with a story about her. However, editor Roger Cook says that freelancers stand the best chance of success with truly original work: "Don't just duplicate what you see in the magazine—the chances are you won't do it as well as we can. Go for something original and spectacular!"
>
> Anything from 500 pounds to 1,000 pounds is paid for a glamour set, depending upon the type of material offered, and the number of pages to which it runs.
>
> CLUB INTERNATIONAL is published by Paul Raymond Publications Ltd., from 2 Archer Street, London W1V 7HE.

Remember that all the quotes you are reading are outdated, and you should not mail material to the publications mentioned until you have checked for current needs. I am showing

you examples of market lists, taking past items to show a broad spectrum of fields. Current needs and even the current address of the publication may differ.

The psychological factor of your being in the United States helps sell foreign markets more easily. However, other than the distance your work has to travel to reach them, the practical aspects of such selling do not differ very much. Follow the guidelines mentioned for American magazines and you will have no trouble.

Be careful to compare prices paid among competing markets. You have no idea what is good or bad in this business since the European and Asian publications have different pay scales, standards of living, and other factors that also determine rates. However, if a publication is unusually low paying, that fact will become obvious by noting the pay of similar circulation journals or book publishers within the same country.

The classic example of this is a large Australian publisher that, among other types of books, puts out illustrated encyclopedias, dictionaries, and reference guides. Periodically the company advertises its needs for photographs in American photography magazines. The need is extensive and a large number of images are purchased from competent photographers. However, the pay is extremely low, even for a company that accepts duplicate transparencies while you sell your originals elsewhere. Unfortunately, the company's literature implies the low pay is legitimate because of the volume of purchases made. It is only by reading a market guide such as the BFP Newsletter that you will learn that other publications of similar material pay several times the buying prices of the Australian photographer in question.

The overseas market is an excellent one for freelancers. The distance your work has to travel will result in no more problems than in selling cross-country. The honesty of editors is the same worldwide, the vast majority making every effort to see that the photographer is treated fairly. This market is well worth your effort.

8

Freelance Photo Stories You Can Take

Every new freelance photographer I have ever encountered, myself included at one time, has trouble generating ideas for material to sell to book and magazine publishers. Usually some excuse is given such as: "If only I could get over to the Middle East to cover some of the violence, my work would be salable." Or, "If only I lived in New York, some editor would love my work and give me an assignment." Or, "If only I lived in a small town in middle America, then I would have colorful events, different from what those sophisticated city editors normally see."

The excuses are endless. There are hundreds I could give, one or more of which have undoubtedly entered your mind. However, the biggest excuse is usually the one created by fear of the unknown. What can I take? I live in a small town, big city, or whatever, and nothing ever happens that is of interest to anyone. What can I do? Where can I go?

This chapter is meant to stimulate proper creative thinking

117

no matter where you live. It contains ideas for major and minor picture stories, all salable and all able to be done anywhere in the country. Not all fit your location and not all will interest you. But the vast majority of them will fit every reader of this book. You can choose to follow them or use them to stimulate your thinking while you find your own ideas. Whatever the case, I will be surprised if you don't find more work in the next few pages than you will have time to handle in the next year.

Photograph the Circus

General circus pictures can be sold individually, to publishers producing posters and to publications of such sponsoring organizations as the Shriners. Guides such as *Writer's Market* and *Photographer's Market* list fraternal organization publications. If you are not certain where to go after checking these guidelines, call the local clubs to find out what publications exist.

Talk with the publicity people to get behind the scenes when the circus first arrives in your community. You might do one photo story on setting up the circus. Another photo story would be on the oldest circus worker and/or the youngest. Photographs can be taken of the specialized acts. If there are teenagers performing, a publication such as *Seventeen* might be interested. If some of the performers had been connected with groups such as the Boy Scouts or Girl Scouts, magazines for these groups would be interested. Another photo story would be on how the animals are kept, trained, and exercised. Each type of story would have a particular audience.

A small town publication such as *Grit* might be interested in family life with the circus. Pictures could show how children are tutored, rehearsals, and other aspects of this kind of nomadic, extended family existence.

A Day in the Life of Your Town's Oldest Worker

This would be a story on whoever in your community is an

active employee of an organization. Leads might come from
the chamber of commerce, city hall, the Social Security
Administration, and talking with major employers. In smaller
communities such people are often commonly known because
they are frequently seen in local restaurants or at one or two
of the area's major stores. Such a photo story, in black-and-
white, would be a natural for a newspaper magazine supple-
ment either within your immediate area or in the nearest big
city. A weekly newspaper and a city magazine might also be
interested. On a national scale, it is possible that a publication
such as *Grit* or magazines for the elderly would be of interest.
Depending upon where the person works, a trade journal or
religious organization journal might also want some pictures.

A Day in the Life of . . .

This can be either a one-shot or an ongoing series. You
spend one day with someone of interest in your community.
This might be the mayor, city counsel, the police chief, fire
chief, or anyone else. You might go so far as to start at his or
her home and then follow the person all day until evening.

Photograph the Largest Hospital in Your Area

One story would be what it would be like to spend a busy
night (usually Friday, Saturday, or holiday nights) in the
emergency room. Another story would be on the birth of a
baby. A story could be done on what it is like to experience an
operation. You might also do stories on some special proce-
dure such as a transplant, if it is done in your area, the day in
the life of an intensive-care nurse, the children's ward, how
mental patients are handled, an alcoholic treatment center
connected with the hospital, and anything else of interest.
These could be run in local publications, magazines for
teenagers, and other sources. Many hospitals have newsletters,
annual report guides, and magazines for which pictures are
purchased. These are natural for them as well. A story based
around children getting their tonsils removed or having some

other normal procedure would be good for magazines related to their age group. If the doctor or nurse is unusual because of community activities, church related activities, specialized organizations, or other community involvement, this may also have an appeal. Publications relating to that organization, either on a local or national basis, will want such work.

How Local Forecasters Predict the Weather

This would be a photo story on television weather forecasters, the people who work for any area government installations, local professional meteorologists, and the like. You would photograph one or more of these people at work, providing brief captions about how they handle things. You could even add humor by including photos of coin flipping, someone throwing darts at a weather chart, and other created photographs meant to be comic. These could be done for a daily or weekly newspaper as well as for a magazine supplement. This might even make a good story for a magazine aimed at children.

Each time you take photographs, talk with the subjects to learn more about them. You may find that they are involved with activities for which there are publications that might enjoy seeing some of the images.

The Hobbies of Your Town's Leading Citizens

Photograph what your mayor, a leading minister, the police chief, and others do to relax. You may find that some handle needlepoint or go fishing, build models, or almost anything else. All of these would make photo features.

Artists in Sugar

Is there a local person who is truly skilled at decorating cakes? A photo story on these creations would be of interest. You might also develop a series of how-to items for larger

circulation publications. For example, you might do a piece on how to bake and decorate a wedding cake. Another possibility would be an article on how to decorate a birthday cake for the most successful party your child ever had.

Handicapped Athlete

This would be a photo story on someone in your town who is both handicapped and involved in athletics. The person might be of interest nationally, within your state, or locally. Everything depends upon the person's skills and story. You can locate such individuals by calling school coaches, services for the handicapped, area gyms, and athletic clubs. You might also try the sports desk of your local newspaper as a last resort. Remember that if the sports department does such a story it will not interfere with running the same story in another section, such as the Saturday or Sunday magazine supplement.

Leisure Time Activities of Your Area Clergy

This would be a series of photo stories, each aimed at a magazine going to the congregations of different religious groups. Publications such as *Writer's Market* list numerous religious magazines, many of which are interested in personal aspects of the life of the clergy. Everything from hobby information to special involvement with the handicapped, elderly, dying, or anything of interest.

New Business Construction

Every time a hotel goes up, a chain restaurant is built, a manufacturing plant is constructed or something else occurs where the business is part of a larger organization, there is a need for photographs. The company will buy these both for magazines, such as the one that the Holiday Inn chain provides for guests, and for internal use with publications

aimed at the employees. If you cannot locate the specific trade journal, contact both the public relations and the advertising division of the company's national headquarters. If the people at the construction site cannot help you, the reference division of your main public library will have such details. You might also contact the office of the president of the company because it can then refer you to the proper parties. This can be done by telephone or more realistically by mail. You will want photographs taken of everything from construction to the opening. You may even sell your pictures to the local outlet for advertising within your area.

Keep alert to the different types of equipment used within the particular structure. Manufacturers of restaurant equipment, special business machines, and so forth may buy pictures of their equipment and use them in the new operation for the company's advertising and for its trade journals. Again the library can supply you with details. Just make note of the names of the manufacturers and their products as you see them. If you are not certain about something, ask whoever is in charge of that department what the equipment might be.

Remember that even if you live in a community of just a few thousand people, a major chain likes to promote the fact that yet another outlet is opening. This is especially true of hotel chains, which advertise that you can use their facilities wherever you travel.

The County Fair

A photo story on how the fair is set up would be good for a behind-the-scenes photo article. A picture story could include the background of people who live with the carnival, traveling to different locations throughout the year. You could go into backgrounds somewhat as you do with the circus. These people are often less professional and more likely to be young, drifting manual labor type workers. This is a radically different story and could eventually lead to a contrasting story between the people of the fair and the people of the circus.

This could be both for local and state publications as well as for national, depending upon what you find. Remember to get into the backgrounds of the individuals, to see other activities they may be involved in.

Look to photo stories on the oldest and youngest participants in fair contests. Each particular contest—handicrafts, cooking, baking—could lead to separate stories for magazines related to teenagers, elderly, and even local people. You may find interesting local sidelights that can keep you in photo stories for city magazines, supplements to your daily newspaper, and so forth throughout the year. Be certain to take notes and to get names and telephone numbers. It is a good idea to have business cards you can pass out in order to get people to contact you. This also makes you more legitimate in their eyes.

Find out if there are new amusement rides available for the first time. Photograph these and contact the manufacturer. Often you can get information as to the manufacturer right on the equipment itself. Read the name plates attached to motors. They are in the open and visible. Just ask the person handling the ride if you could study it for a while. If worse comes to worst, the library can then be of assistance.

Contact the manufacturer of the rides to learn not only of the manufacturer's interest in your pictures but also to see if the company is actively engaged in designing new amusements. It it is, you might have another photo story for a general interest publication such as the new *Saturday Evening Post*.

Are there teenagers selling refreshments and doing other work at the carnival? You might have a photo story, either from the fair alone or through combining pictures with photos taken at ballgames and other activities, in order to do a story on unusual ways teens can earn money. Depending upon what combination of events you are able to photograph, this could lead to a story in a national magazine.

Occasionally, you will be asked by entertainers and other people involved with the carnival or other traveling shows for

copies of photographs you have taken. The people will want them for either a scrapbook or for personal publicity. Some will be honest and others will not. But all of them are living a kind of nomadic lifestyle where income is not always predictable. Most such people are either slow to pay or don't pay at all when you agree to let them send money after they have left. If you decide to sell prints to such people, make certain that you get cash in advance or on delivery.

A First Pet

This would be a photo story on a small child playing with a chicken, puppy, kitty, or other young animals. You would photograph the child from the time the pet is first introduced. You might even photograph the child at a pet store if this is the way it is obtained. You work until the child is exhausted, taking pictures from all angles including lying down on your stomach and looking through grass, carpeting, or whatever. You might even photograph for two or three days, depending upon the circumstances. You may also have to photograph more than once with a different child each time in order to get something unusual.

Such pictures are ideal for publications on a seasonal basis. The implication can be that the present was given for Easter or Christmas. Photographs can be sold straight or they can be sold as part of a story on the type of pet a child should be given at different ages, the proper care, and the feeding of a new pet. Remember that seasonal stories should be submitted from four to six months in advance at the very least. Fortunately, this kind of photo is not dated since children and pets have been around for years and will continue to be. Just be certain nothing in the picture shows the year or otherwise identifies the time, such as a car or the length of the skirt on the mother. Then you can continue selling such pictures year after year forever.

If you do photograph children and pets on Christmas Day, be careful when using color. The eye is drawn to warm colors.

A photograph of a child near some new toys or boxes could be ruined if the objects are red. The eye will be drawn away from the child and the animals. Either rearrange things, shift yourself, or utilize black-and-white under such circumstances. Take both black-and-white and color to be certain you can cover yourself for any type of publication.

Hobby Store Opening

The public is spending more than ever on hobbies. Each time a new coin store, toy store, stamp store, or other hobby business opens in your area, investigate the possibilities of photographing it. One or two general photos can be sold to announce the opening in the various trade journals and collector magazines. If there is an unusual security system that the owner will discuss, you can sell pictures not only to those trade journals aimed at the store owners in the field but also to security magazines. If there is unusual architecture, architecture and interior design publications may be interested. (Check with the architect to see if the design is original or similar to past work which may have been publicized.)

Institutional Food Service Photography

Is there a new food service being put into your area's school system, hospitals, or other institutions? One or more changes can result in a story. Likewise the removal of a food service can be of interest to the public. Your photo story will be aimed at institutional magazines (trade journals) both relating to the institutional food business and to the particular institutions such as hospitals, schools, etc. Photographs of the new operation being installed and in use, patient reaction, student reaction, or whatever, coupled with quotes from the people involved will make your sale. You can have quotes from the people using it underneath photographs showing them enjoying the facility and quotes from the people in charge as you show them running the system. You might also have quotes

from the designer. Such stories are of interest regardless of any changes. The visual is extremely important to the sales because the people reading the publication want to see what is done so that they can either duplicate it or go a different route. When something new has been added, be certain to give credit to the architect, interior designer, institutional designer, and anyone else directly involved.

Construction and Architecture Photos

Make contact with your area architectural and construction firms. Find out when a project is going up that is unusual in some way. This might involve a new type of construction material or a new approach to the work. I have done stories as broad as one on the use of a new type of concrete high rise, utilizing special concrete and precast paneling as well as one on a construction firm that utilized 7,000 electric blankets in order to dry materials at night so that construction could continue during periods of bad weather. Remember that even a small, isolated community can be the location for an experimental construction project. Often a firm interested in a new method for building on a nationwide basis may try the technique on a small hotel or other building in a tiny community. Once everything is worked out where the cost of any mistakes can be held to a minimum, the operation will move to a major city where mistakes could run into the millions if they were made. However, even when a test project is erected, if no one is quick to get the story and you live in a major city, you can photograph the second project going up and still be first with the story.

Landscape Photography

Talk with landscape architects, flower store owners, and other people dealing with the selling and designing of plants and gardens. See if anything unusual is going on in your area

or has gone on in the past. Often magnificent, hidden gardens and specialized patios exist in very tiny areas no one knows anything about. When you photograph them, you can make black-and-white sales to your area newspaper, and both black-and-white and color sales to major magazines devoted to the field. When such gardens are professionally designed, you can make a sale to trade journals as well. Also check the background of the people who have done the gardens to see if you can do a story for the trade journal for the publications related to their jobs. Keep in mind that every trade journal related to business is likely to have a special section in which there are stories concerning leisure time activities by professionals. Thus, a magazine devoted to the financial world is quite possibly going to have a section in which you can sell a photo story on how a banker enjoys his or her garden or an attorney who is involved with nature photography. Whatever the case, do not assume that just because a publication is devoted to something such as finance, it is not also interested in leisure time activities. The space will be relatively minor compared to what will be given for a photo feature directly related to the interest of all the readers, but you can make a sale.

Old Car Collectors

Find out who in your area owns antique cars. You can learn this from clubs listed in telephone books, checking with your area newspaper, talking to various new and used car dealers in town, talking with auto mechanics, and similar approaches. One general story concerning one or more collectors could go locally. You could also sell photo stories to antique car journals such as the Krause publication *Old Cars*. Additional sales could go to the publications put out by the manufacturer such as *Ford Times*. You might also do a photo story for one or more trade journals relating to the business the collectors happen to be in. A photo story for a teen magazine might be

appropriate if a teenager is able to use the cars for various activities.

A Day in the Life of an Airport

This would be a behind-the-scenes story on your local airport. You would photograph all activities, from the security personnel headquarters through the loading of airplanes, food, and fuel. A talk with the airport management as well as the managers of the various airline operations will get you behind the scenes. Such a photo story is both local and good for possible use in travel publications, magazines aimed for children, and others.

The Area Amusement Park

Go behind the scenes at your local amusement park just before the season opens and during the season. You will want to do a photo story on getting ready for the season aimed at your local newspapers and magazines. A photo story on the way the park is maintained and operated, such as one about the men who walk roller coasters in order to keep them functioning properly, would appeal both locally and nationally to the young. Smaller children, who delight in using the rides, would also like a behind-the-scenes look at how they operate.

The Best Restaurants in Town

Photograph the interiors and some of the meals, including food preparation, of five or six of the most sophisticated restaurants in your community. Choose those that are extremely expensive, offer continental dining, or otherwise are likely to go to a great deal of trouble in preparing each item. A basic photo story can be run in your local newspaper, the newspaper magazine supplement, or a local city magazine. You will also find that pictures are in demand for advertising

purposes and for the owner's own publicity. You may even find that you have some stories for one or more trade journals, perhaps on how the restaurant publicity was handled. Remember that each time there is a feature story on a business that is not paid for, it is like free advertising. Trade journals will want photo stories showing how this came about and how businesses of a similar nature located in other communities can arrange to have the same kind of publicity.

9

Filing, Mailing, and Other Business Essentials

I once had a very logical approach to business. When I wanted to let someone know who I was after photographing the person on the street, I would write my name and address on a torn piece of paper, often using a corner from the wrapper of a McDonald's Big Mac. My photographs were filed by tossing the negatives in one drawer and the contact sheets in another. My mailing was done by sticking the pictures in an envelope, sending them without any protection, and then wondering why they were returned looking as though they had been trampled by an enraged football team. It was the kind of brilliant business sense that made freelance sales a rarity. If this sounds familiar, the following information will help you.

Get a business card. This is a very simple device that includes a business name, your name, telephone number, and either your home address or a post office box number. I prefer the box number because my home address changes with

enough frequency within a city that the cards would not be used before I would have to place a new order. The telephone number also changes, of course, but not so often, and it is easy to write in the new number. Changing an entire address without changing the business card somehow looks cheap.

The business name can be anything you want. I used to feel a little silly calling myself a business since I had no studio, worked a full-time job, and used closet space to store my photography equipment. However, the business name helped establish me as a legitimate concern, and I have maintained the same business name for several years. Now that I am incorporated with a full office wing in my home, it makes a great deal of sense. The business name is also well established.

The telephone number you include should be one that is answered all day. You might even wish to use an answering machine if no one will be at that number to take calls. If your work is good, there is a chance you will be called either for additional pictures relating to the picture story you sent to an editor or with a go-ahead based on your query. Having no one available to answer your calls can end your freelance career before it begins.

I like the idea of having a twenty-four-hour telephone line, especially since one of my markets is in London, England, and likes to call me at all hours. I have tried answering services and have found that they are too expensive and often unreliable. A twenty-four-hour answering service costs as much in six months as the purchase price of a good quality answering machine. I am a firm believer in back-up equipment, so I have two machines, equal in cost to something short of a year's regular answering service charge. Maintenance is next to nothing, and the machines are extremely reliable. They also give my exact message in the way I want, another plus. For a fee, I can also get a beeper unit that would allow me to call the machine from anywhere in the world, play a tone generated by my beeper, and have my messages given to me.

Compare answering machines before buying them. My

preference is for the type that uses cassettes rather than built-in tape. If the cassette is damaged, I can change it. A damaged built-in tape might mean a service call. I also like the electric machines you plug into the wall. Power outages in my part of the country frequently mean telephone outages as well. So I do not feel hampered by the loss of a self-contained power source.

You should also talk with independent electronic repair shops to see what they recommend. I was told to buy a specific line when I bought my first machine because it is so easy to fix. My particular machine is supposed to be one of the easiest to maintain. Almost every repair, according to the repair people, requires snapping out one piece and substituting a new one. You should price different units that fit your needs, then talk with the repair people to learn which machines are the best. Just be certain the individual you ask handles numerous brands rather than just one company's brand.

Your business card is very much like a press card even though it has no official status with anyone. Cards provide you with instant credibility. You are giving the recipient your name, mailing address, and telephone number. The person can check you out and contact you, anonymously. It is a situation in which the person is more inclined to cooperate, both with signing the release and with providing a name for the caption of a photo planned for newspaper or magazine use. If all else fails, give the person your card and ask to be called at his or her convenience.

Business cards can be of help with the police as well. In a not particularly life-threatening situation where you are trying to take pictures, amateurs and curiosity seekers are asked to leave. Professional photographers accredited with a newspaper are allowed to stay, and in many cases, a freelancer can stay if he or she presents a business card. The card is not confused with a legitimate press pass but rather serves as a sign that you are professional and do have more business being there than a curiosity seeker with a camera.

The filing of photographs, slides, and negatives is another critical area for the freelancer. It does you no good to have hundreds or thousands of salable photographs if you have no retrieval system to match.

There are numerous ways to handle slides and negatives, all of which are good. Many commercial systems are available, each of which involves the housing of individual negative strips and slides. The prices range from a few cents for acetate sleeves to hold individual strips of six 35mm negatives or three and/or four 120 negatives to several hundred dollars for a free-standing slide holder with a built-in light and a capacity for thousands of slides.

I have found my system to be extremely functional over the years. I use plastic pages that fit into notebooks. Some of the pages hold 35mm slides in groups of twenty per page. Other pages hold 35mm negatives, 120 negatives, 8 x 10 prints, contact sheets, and almost anything else. Pages are available for literally every format slide, negative, and print up through 8 x 10. The pages all fit in standard three ring binders which can be put onto a shelf.

The type of holder you buy may affect the life of the product. There is a plastic called PVC, said to be destructive to slides over time. This is a plastic used in many of the holders sold to hold slides, including the type I have bought for close to fifteen years. But my images have stayed free of deterioration during that period except for Ektachrome slides, which were processed in the older color chemistry. Even the older Ektachromes have not deteriorated any more than expected for that type of film. Thus, I cannot say from personal experience that the PVC reaction is going to be a problem. However, since there are holders in which PVC is not used and since problems have been reported, you might wish to buy the non-PVC types if you are concerned with longevity.

Plastic holders receive mixed reviews for negative storage. There are numerous ways the plastic could damage images including through melting when heat is too high. Ideally, all your storage is done in an air-conditioned room with rela-

tively low humidity. However, this is not always possible and the deterioration of the plastic to the point where it affects the negatives is a distinct possibility.

One answer for many photographers is to place the negatives in sleeves known to be chemically inert. These are available from almost every camera store and are extremely inexpensive. Some come with a cardboard holder with six sleeves attached, and others are loose. Although both types are good, if you are concerned with chemical purity, there can be slight problems with the adhesive used to attach the sleeves to the cardboard.

Next, take the plastic pages meant to hold 8 x 10 prints, and insert two different contact sheets back-to-back. Then, instead of having the negatives in separate pages, insert the negatives into the sleeves and place them between the two contact sheets. Let the negative sleeves be loose rather than clipped together in some way to further prevent damage. This gives the best protection most people will ever get.

Please keep in mind that this chapter is discussing routine storage. I am not discussing archival storage meant to preserve the negatives for a century or more. However, if there is reason for long-term preservation, special chemically inert holders are available, although they are somewhat expensive. My negatives have remained undamaged for more than twenty years with my storage methods and have shown no sign of deterioration. I doubt that I will have problems for any time in the foreseeable future. This is an individual matter, however, and you should be aware that all I am suggesting will not insure the extremely long-lasting quality of material stored in archives.

Basically, I have two systems for my notebooks. One set of notebooks holds slides. A second set holds the negatives and contact sheets.

Slides have always been a problem for me to store. I have yet to figure out a satisfactory system for cross-referencing them to a list of subjects. Fortunately, I have enough images so I can store them in notebooks according to topic. For

example, each model with whom I work frequently enough to have a notebook and several pages of slides is filed by her own name. Thus, one notebook might be marked "Wanda Willow-waist," and another might be marked "Sonia Suntan." Subjects are likewise filed so that I have a notebook for circus images, another for the rodeo, and a third for the Grand Canyon. If there aren't enough slides of a subject for its own notebook, such as pictures of individual homes, offices, and businesses, then I lump them together in a notebook marked "Architecture" or whatever else is appropriate.

When I have several subjects, all of which fit into a category such as architecture, then I make certain the slide pages are separated according to the topic. If I photographed the homes of six people, each home gets its own page(s) and is marked with the topic. I use indelible marking pens and write on the edge of the plastic pages involved, keeping the ink away from the slide emulsion. The slides might be in the same notebook as images of New York's museums, or if I have enough subjects, I will have one notebook for museums, another for apartment buildings, and a third for homes, businesses, or whatever else is appropriate. Eventually I will pull some of my architecture work and file it under the architect's name as well. Cross-referencing can be done through taping a 3 x 5 card that contains the appropriate information to the inside cover of the notebook.

Contact sheets are something else. I give each one a number and write the same number on the edge of the negative holder in indelible ink, while the negatives are out of the holders. I do not put the negatives in the sleeves until the ink has dried for fear that it might otherwise seep through the sleeve onto the negative. This has never happened to me, but I don't like to take chances.

Once each sheet is numbered, you are faced with the task of making a file system for retrieval. I know of no shortcuts for this, and I have looked frequently. This is a time consuming chore that will eventually make life quite simple for you. Getting started is the only part that is a problem, however.

I take each subject and make a 3 x 5 card for it, cross-referencing as much as possible. Thus one card might read "Models." Another might say "Sonia Suntan." A third would be filed under bathing suits (she is wearing a bikini). A fourth would list her agency, if any. A fifth might list the city (Dead-At-Night, Iowa—Models) with appropriate cross-references. If she is by the beach, a card might be "Beach Scene with Model" or whatever is appropriate. The most important point to remember is that ten, twelve, or fifty years from now, your images might still be salable, and you will be selling from your files. How can you identify a picture that far from now if you do not have some sort of good cross-reference system?

Once I have the card headings, I put the contact sheet number on which the image can be found. Unless I have several different images of similar subjects on the same contact sheet—a rare occurrence—finding the subject with just the sheet number is easy. For example, suppose you have three different models photographed during the same session, and you happen to have all three on a single sheet, perhaps twelve frames of each. Under such circumstances I would list the particular model's name, the sheet number, and the specific frames, such as "13-24." If all three are in one frame, I might put a card reading "Sonia Suntan (with Wanda Wallflower—Left; Millicent Midwife—Middle." The specific form you use is a personal matter.

The numbering system for the contact sheets can go any way you find effective for you. For example, you might want to number your sheet from one to whatever, regardless of the format or type of film. Or you might want to do what I have done: Designate a letter before the number to identify the format. Thus "A" might list all negatives taken with 120 black-and-white film, "B" might list all negatives taken with 35mm black-and-white, "C" and "D" would indicate color negative film for comparable formats, and you still have all the other letters of the alphabet for special use, such as when you have 4 x 5 internegatives made. Then a model's name might have such designations on the card as "A-17; A-35; A-106; B-17, 18, 19; B-37, 38; and B-100.

The final approach you use is a personal decision. You must work with something that is easy to handle regardless of your volume. My system was somewhat awkward when I started because I had several years' work to do. However, once the backlog was filed, maintaining the file has been easy.

Mailing your photographs is the final consideration of this chapter. You must be able to provide maximum protection at minimum cost, especially since prices are so high for postage.

I mail all my film to labs outside my city for processing and feel that you would be perfectly safe to do so as well. Film is seldom lost, and the only problems are usually caused by the mailer's carelessness. I have mailed thousands of rolls of film and lost only one—due to my own mistake.

Before getting film ready for mailing, put your name and address on the outside of each roll or cannister. I use pre-printed labels, using cellophane tape to secure them. The adhesive attached to the surface of the labels will not work. It adheres perfectly to film cannisters until it dries. Then it falls right off. By placing a clear tape over the surface and around the cannister, you are safe. With 120 roll film, I place the label and then the tape around the foil I have saved from removing the film. I do not return the film in the original box, but if I did, I would put the label on that. Then I would tape the label and also the ends of the box to ensure that the contents did not get separated. Just be careful to avoid sticking the tape to the paper backing because it is difficult to remove for processing when it reaches the lab.

The next problem is the mailing envelope. A heavy duty mailing envelope reinforced at the seams with tape is essential. I prefer the type that is padded with a layer of plastic containing air bubbles to absorb shock. There are a number of these, the "Mail Lite" line being one. These provide protection at least equal to a padded envelope and weigh less, reducing mailing costs. Many labs provide their own, non-padded envelopes, the majority of which are not particularly sturdy. I prefer to substitute my own if there is any question. Remember that while the labs do not want you to lose your film, there is a chance that a new type of envelope has been

purchased for sending to customers as a way of cutting costs. If such envelopes prove to be less effective than anticipated, hundreds or thousands may be used before the defect is discovered. Thus, you should not assume an envelope is safe, but use the best protection you can find. Look for weak points, such as seams and edges, and reinforce them.

Prints and slides mounted in plastic sheets should be sent in what are commercially known as Photo Mailers. A Photo Mailer, and there are a number of varieties, is a heavy duty envelope slightly larger than the prints it is meant to hold. The slight oversize allows for the insertion of the pictures and two pieces of corrugated cardboard for protection. Corrugated cardboard can take mild abuse in handling without letting the prints get damaged. Regular cardboard cannot.

Commercial holders for mailing prints are available through most camera stores. However, if you have pieces of cardboard of appropriate size, and these can be cut from a cardboard box, you can save money by buying a large quantity of appropriately sized envelopes and making your own. Usually, an 8 x 10 print can be mailed in a 9 x 12 envelope, cardboard included. In some cases you may need to go to a 10 x 13 size, especially when mailing plastic sheets of slides. (Note: Use a plastic sheet for mailing slides, even if you are sending a single slide. Mailing slides in the boxes the labs return them in may result in a wood or plastic splinter being broken and jammed through the emulsion.)

The fact that you are sending a plastic sheet capable of holding either six (120 roll film in square format) or twenty (35mm format) slides does not mean that you should fill it. If you have only one or two 35mm slides, use the sheet anyway.

The plastic sheet is an excellent tool for the editor. The sheet can be held so it is illuminated by the sun, room light, or a light box. Coffee can spill on it and jelly doughnut filling can ooze onto the surface, then be wiped clean without the slide being damaged. A slide can be removed for viewing under magnification or by projection, though the risk of fingermarks is reduced since it will be protected when checked rather than each slide being handled when taken from a box.

The self-addressed, stamped (adequate postage for the envelope, pictures, and cardboard) return envelope must be included. This can be done by taking a same size envelope and folding it in half or by having the return envelope, complete with cardboard, inside a larger envelope. For example, suppose you are mailing 8 x 10 prints which fit, along with the cardboard, into a 9 x 12 envelope. I would make the 9 x 12 envelope my return and put name, address, and postage on it. Then I would insert the 9 x 12, cardboard included, inside the 10 x 13 envelope addressed to the publisher. The photographs would also be included in the 10 x 13 but would not be in the return envelope. This provides proper protection and an obvious return holder.

An overseas mailing will not have a stamped envelope. Instead the envelope will be properly addressed, including the addition of the words *United States of America* in the return address, and adequate International Reply Coupons included to cover the cost of postage for return.

Photographs should always be mailed first class to a publisher though the return envelope can be mailed third class if timing is not critical. The reason for mailing first class is psychological. I have known editors who told me, in effect, that when a photographer does not send his or her work first class, the implication is that the photographer does not respect the pictures enclosed. The editor feels that the pictures have been rejected numerous times and that the photographer is hoping to sucker someone into taking them. The use of first class implies this is the first time they have been out and the photographer is proud and anxious to mail them. Such reasoning is nonsense, of course, but since it exists among some editorial personnel, there is no sense in mailing your work any other way.

Talk with your post office about overseas mailing. There are different ways to do this inexpensively if you do not include writing material. One rate sends everything air mail at a rate that is far less than the per-ounce charge for a letter. If the person you talk to is unfamiliar with the service, telephone the postmaster. There is little enough call for such service in

most cities that some employees are not totally familiar with the rates.

Overseas mail requires a custom declaration form. This is a self-adhering, small sheet of paper that fits onto a corner of the envelope. On it you should mark the words, "Photographs of no commercial value." Otherwise you will be charged import duty. Mark it this way regardless of what the sale might mean financially.

Insuring your photographs is a lost cause due to a number of rulings made in cases where insured pictures were destroyed in the mail. Without going into extensive details, it has been held that the value of photographs is based on the price paid in the average sale of those pictures. If you can prove that your work has sold for a certain amount of money and the most recent mailing of those photographs resulted in their irreplaceable loss (slides, for example), you can collect the average amount you have received. However, if you are just beginning your freelance career or if the pictures have never been offered for sale before, then you can only collect a few dollars, representing the value of replacement materials. The fact that a magazine might pay you $1,000 is of no concern when collecting on the insurance. All that matters is whether or not those same pictures have ever earned money in the past.

The reasoning is both fair and unfair. However, all that really matters is that you recognize the potential for loss, keep careful records, package properly, and mail first class. Do not bother insuring your work because it is a needless waste of money.

Mailing your work is an essential aspect of freelancing. By handling this stage of marketing properly, you will probably never experience a problem. However, the burden of safety is on you and the materials you utilize. Thus, always work carefully and thoughtfully to insure that the pictures will arrive and be returned without incident.

10
Now Try It!

Now that you have finished reading this book, I would like to tell you something about yourself. I know what I am about to say is true because I have been there myself when I was first starting to freelance. More important, I have talked with hundreds of successful freelance photographers from all over the United States, and I know they have all felt the same way. You are not unique.

I suspect you read this book for one of two reasons. Either to sell your work you needed technical information which you lacked, information you hopefully now have, or else you read this book to avoid actually trying your skills at freelancing. Many photographers, myself included at one time, spend every spare hour reading about selling their work rather than getting out, taking photographs, and then trying to market them. If this is what you are doing, get off your chair, load film in your camera, and go to work.

Don't tell me you can't sell your pictures to newspapers,

magazines, and others. Don't tell me you are too old, too young, a woman at a time when only men are needed, a man when women are wanted, a member of an ethnic minority, ethnic majority, have only one leg, or any other excuse. There are paraplegic photographers and at least one photographer who sells professionally lacks the use of both arms and legs. He has special equipment he operates with his teeth in order to focus, compose, and take a picture. He uses a motor drive to advance the film after each picture and an assistant to change the lens. One professional photographer is blind in one eye. In fact, regardless of the excuse you give me as to why there would be bias against your work, I can find a successful freelancer a little worse, a little older, younger, or whatever.

The fact is that regardless of what you have been telling yourself, all the vast majority of editors and publishers are interested in doing is finding and purchasing quality photographs. They don't care who took them. They don't care about anything except the final image and how it relates to their needs. In some cases you may not even know what the publisher's needs are. The greater the variety of images you send, the more sales you get.

Your educational background is meaningless, too. If you left school in third grade, I'll show you a success who never went past second. I don't care if you have trouble speaking. The image recorded by the camera is all that matters to anyone. I am not educationally qualified to work for most of the magazines to which I sell my freelance work. Yet my gross annual income is far higher than the majority of the staff people who could turn down my application for employment.

One reason you haven't sold is because you are making assumptions. Perhaps you are saying, "Who am I? It's great for Ted Schwarz to make all these comments because he's on top of the heap. I'm at the bottom and being crushed into the ground."

Sure, I am on top, and that is why I have written this book. But nobody knew who I was when I started. Let me stop

trying to sell my work for four or five years, and editors aren't going to remember me. In fact, I will probably be faced with a whole new set of individuals considering my work, none of whom ever saw what I did. I would be right back on your level under such circumstances, but I wouldn't stay that way for long. I would climb right back on top, and do you know why? It is because I would continue to aggressively market my material.

Nobody is going to magically call you to work as a photographer for a magazine. No one is going to telephone from a publication and ask you to take pictures—unless they know who you are first. How do they learn your name and the quality of your work? By seeing your appropriate photographs.

I have a friend who is a beginning freelancer who also wants a full-time job in photography after spending fifteen years as a construction worker. He would delight in working for a newspaper and has been trying to assemble a portfolio to take to the photo editor. He is also trying to sell spot news photographs.

Last week my friend chanced upon an auto accident in which a man on a bicycle was injured. His photographs were excellent, and he was delighted when I praised them as we had lunch together.

"Did you try to sell them to the newspaper?" I asked, upon learning that he was the only photographer on the scene.

"No, I'm saving them for the portfolio I will show when I ask the editor for a job."

"Why didn't you try to sell the photograph anyway? You would have retained the negative. Then whatever the paper paid would have given you that much more money to spend on putting your portfolio together."

"It was a really busy news day. Didn't you see all those pictures they ran?"

"Did they tell you it was a busy day for pictures?"

"No. I never called. But they would have turned me down. That was obvious from the pictures they did run."

"If you didn't call and if you didn't know it was a slow news day when you took the pictures, then for all you knew they had plenty of space to use your work. You made an assumption without having any knowledge. I agree that the day was such they probably would have turned you down. But they might not have done so. You might have had a sale instead of a situation in which you didn't even make the attempt. You potentially cost yourself money and all because you didn't pick up the telephone and call or go over with your exposed negatives. Newspapers are always happy to process film for you, just in case the news pictures you have are of value."

The point of all this is that my friend made an assumption, not a sale. You are going to be turned down from time to time. I have been rejected numerous times, and not just when starting out. In the most recent mail, for example, I received two rejections—and an acceptance accompanied by a check for more money than I earned the entire first year I freelanced. More important, the check was from a publication I *assumed* would not be interested in my work. I also made the assumption that the other two couldn't possibly live without Ted Schwarz photographs. Had I followed what I believed to be the key to my success, I would never have mailed the pictures to the publisher who bought them.

What all this means is that no one can accept pictures they don't have. Certainly someone may turn you down. There is a good chance you will be rejected many times. But *nothing* is going to be accepted until it is seen. I would rather have ten rejections to every acceptance than have no acceptances because I never tried to market my work.

Usually the fear of rejection is irrational anyway. What will happen if you are rejected? Will your camera be smashed in front of your eyes? Will you lose your job? Will your firstborn child be sacrificed to the gods? Will people laugh at you on the street and see your name smeared in the headlines of every newspaper across the nation?

No! Nothing happens when you get a rejection. You're no

better and no worse than you were before. Your life goes on exactly the same way. No one hurts you. No one cares. The editor will be just as anxious to look at your pictures the next time and the next. All you have done by mailing off your work for consideration is place yourself in a position to be accepted, not rejected. If it doesn't happen, you try again. If it does, you bank the check.

Now go out and try to freelance. You have the basic tools from the pages in this book and from your own ability. Your first sale may come immediately or not for a week, a month, or many months. It doesn't matter. There is no timetable for success in this business. All you can do is try your best, then try again and again until you get there.

That's what I did years ago. I had no more faith in my ability at that time than you do now. The rejections hurt, and I wanted to give up. I still don't know why I continued trying as I did, though I'm glad I did. The result is that I can now work full time in the field I love, and I have even written this book, a book I wish I could have read when I first started.

So get to work! Try the freelance photography you know in your heart you are driven to do. And when you make your first sale, write to me in care of this publisher and tell me about it. If you have troubles and a question that remains unanswered, write me about that, too. The letter will be forwarded to me, and I will answer as soon as I get it. I *do* care about your success and look forward to the day when I can start seeing your by-line right alongside my own.

Good luck!

11

References, Associations, and Other Places to Check

The Bowker Annual of Library and Book Trade Information,
published by R. R. Bowker Company, New York. Out
every year (1978). Contents—legislation, funding, grants,
statistics, directory of book trade organizations.

Photographer's Market, published by Writer's Digest Books,
Cincinnati, Ohio.

Writer's Market, published by Writer's Digest Books, Cincin-
nati, Ohio. Out every year (1979). Contents—how to
submit work, copyrighting, rights, taxes, markets, awards,
government sources and information, organizations.

American Publishers Directory, published by K. G. Sour
Publishing, Inc., New York. Out for first time 1978.
Contents—guide to publishers of books, journals, maga-
zines, directories, reprints, maps, micro editions, braille
books, and book clubs (alpha listing).

American Book Trade Directory, published by R. R. Bowker
Company, New York. Out for 24th time 1978 (approxi-

mately every 2½ years). Contents—retailers and antiquarians in U.S. and Canada, wholesalers of books and magazines in U.S. and Canada, book trade information, auctioneers, greeting card publishers, exporters, publishers in U.S. and Canada.

LMP 1979 (Literary Market Place/Directory of American Book Publishing), published by R. R. Bowker Company, New York. Out annually. Contents—book publishing, associations, agents and agencies, services and suppliers, direct mail promotion, radio, television and motion pictures, magazine and newspaper publishing, names and numbers.

International Literary Market Place 78-79, published by R. R. Bowker Company, New York. Out every two years. Contents—159 countries, publishers, major booksellers and libraries, book trade organizations, library associations, literary agents, book clubs, book trade and literary reference books, and periodicals, literary associations and prizes, international organizations.

International Academic and Specialists Publishers Directory, by Tim Clarke, Bowker, New York, 1975.

American Book Trade Directory, every three years. Published by R. R. Bowker, New York. Contents—publishers, booksellers, private book collectors.

The Writers' & Artists' Yearbook, published by Adam and Charles Black, 4, 5, & 6 Soho Square, London W1V 6AD.

Photography Market Place, edited by Fred McDrrah. Periodically updated.

Photography and the Law, by George Chernoff and Hershel Sarbin, periodically updated. Amphoto.

Photography: What's the Law? by Robert Cavallo and Stewart Kahan, published by Crown.

AASP—American Association of School Photographers, Inc., 3555 Cowan Pl., Jackson, MS 39216.

ARPA—American Racing Press Association, c/o Judy Stropus, 68 Weston Rd., Weston, CT 06880.

ASMP—The American Society of Magazine Photographers, also known as The Society of Photographers in Communication, 205 Lexington Ave., New York, NY 10016.

APA—Architectural Photographers Association, 435 N. Michigan Ave., Suite 1717, Chicago, IL 60611.

API—Associated Photographers International, Box 206, Woodland Hills, CA 91365.

AFP—Association of Federal Photographers, 7210 Tuler Ave., Falls Church, VA 22042.

EPIC—Evidence Photographers International Council, 10322 Lake Shore Blvd., Cleveland, OH 44108.

IFPA—International Fire Photographers Association, 588 W. DeKoven St., Chicago, IL 60607.

NFLPA—National Free Lance Photographers Association, 4 E. State St., Doylestown, PA 18901.

NPPA—National Press Photographers Association, PO Box 1146, Curham, NC 27702.

PSA—Photographic Society of America, Inc., 2005 Walnut St., Philadelphia, PA 19103.

PPA—Professional Photographers of America, Inc., 1090 Executive Way, Des Plaines, IL 60618.

RPS—Royal Photographic Society, 145 Audley St., London, W1Y 5DP, England.

UPS—Underwater Photography Society, Box 15921, Los Angeles, CA 90015.

Bureau of Freelance Photographers, Focus House, 497 Green Lanes, London, N13 4SP, England.

Market Guide, U.S. & Canadian Papers. Published by Editor and Publishers, Inc., 575 Lexington Ave., New York, NY 10022. (212) 752-7050

Syndicate, International listing.

Index